1

2

3

1

2

3

4

5

6

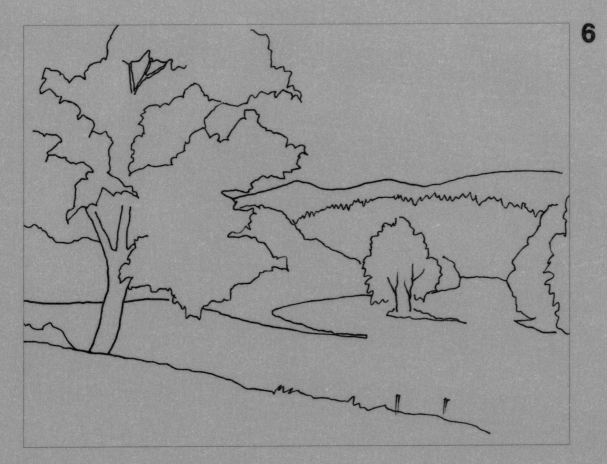

7

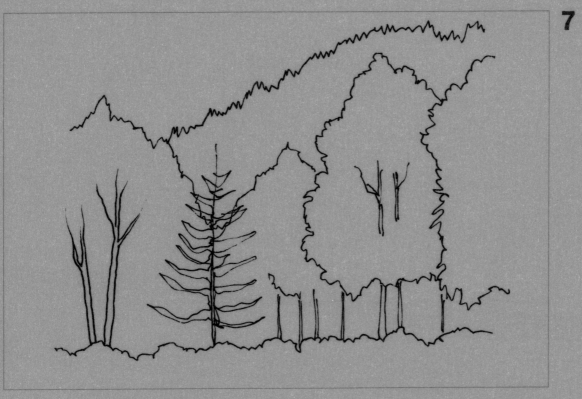

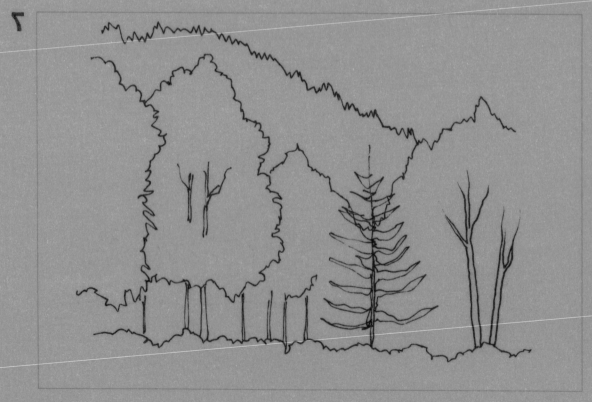

8

9

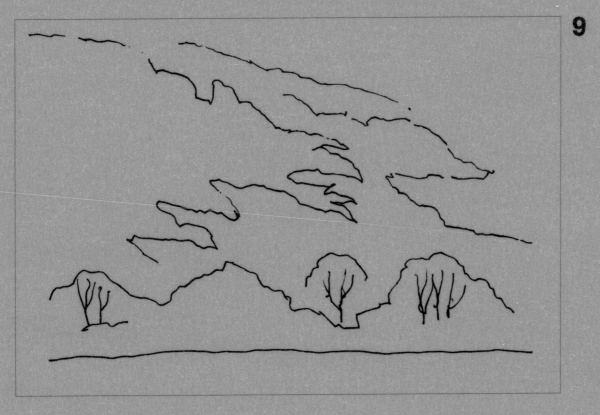

8

e

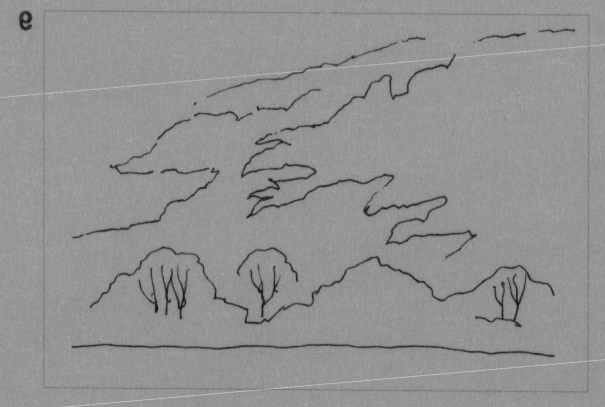

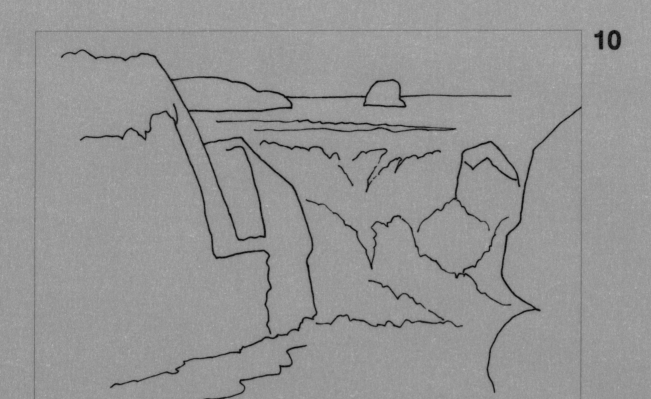

10

11

12

13

14

13

12

14

15

16

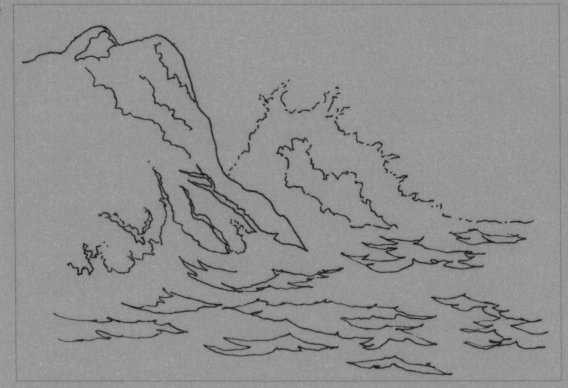

15

16

17

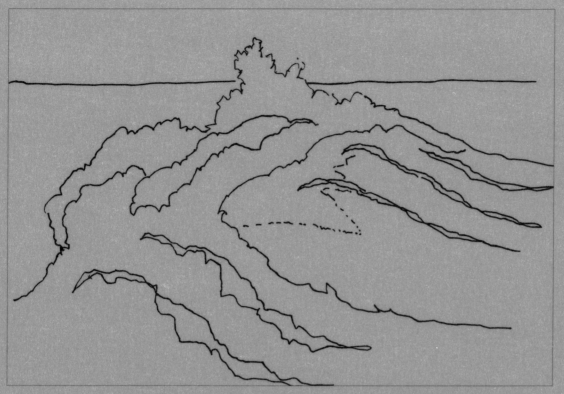

18

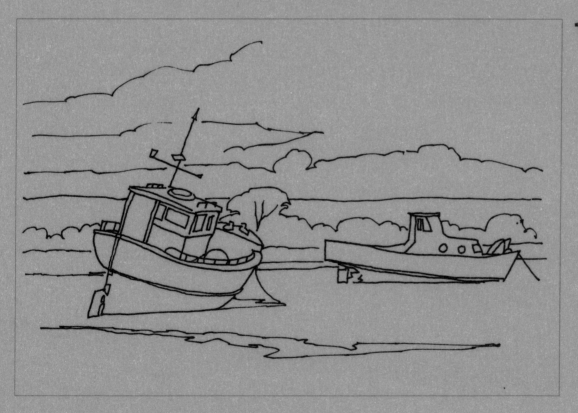

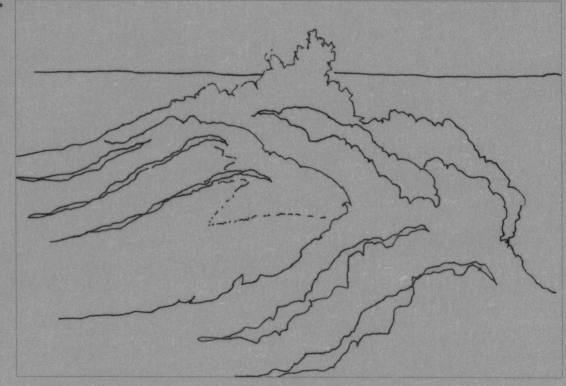

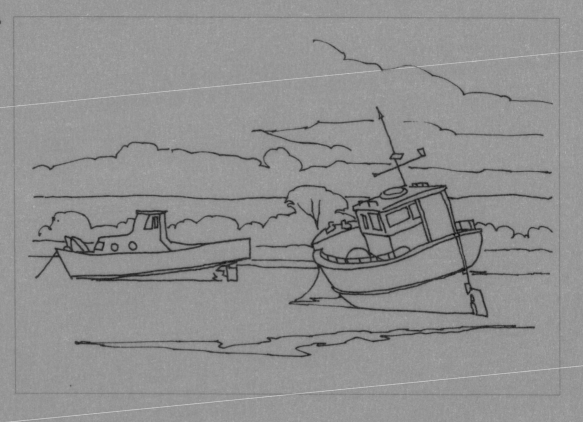

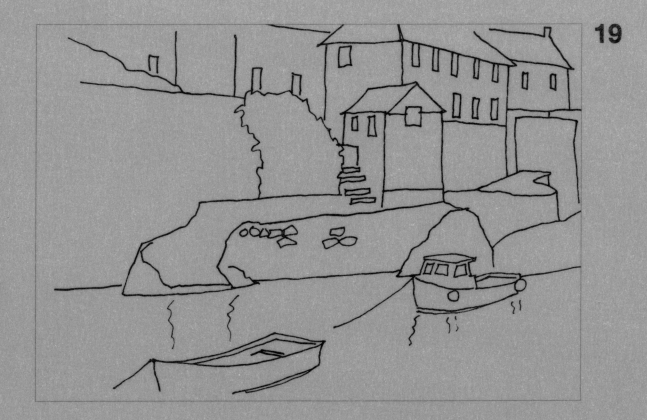

19

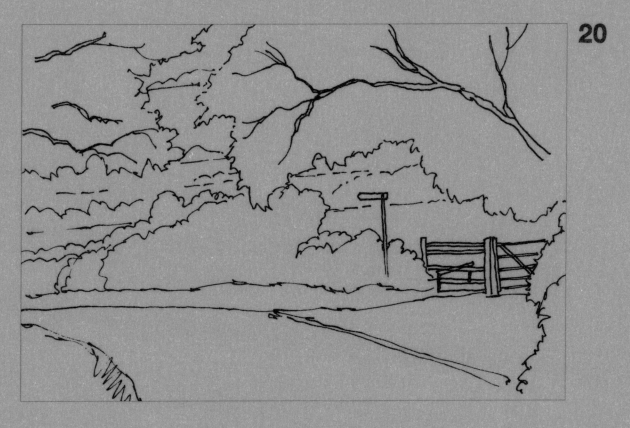

20

19

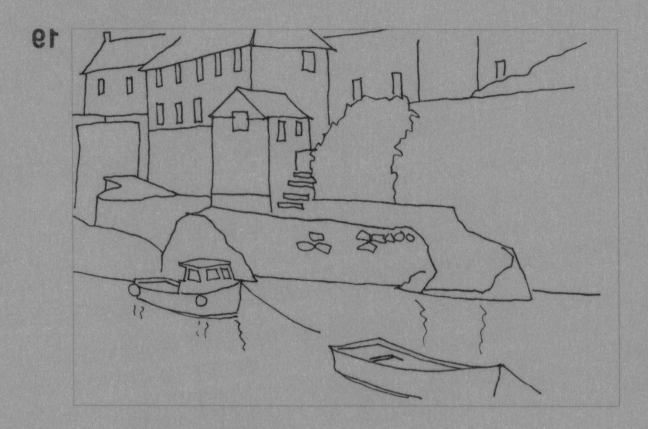

20

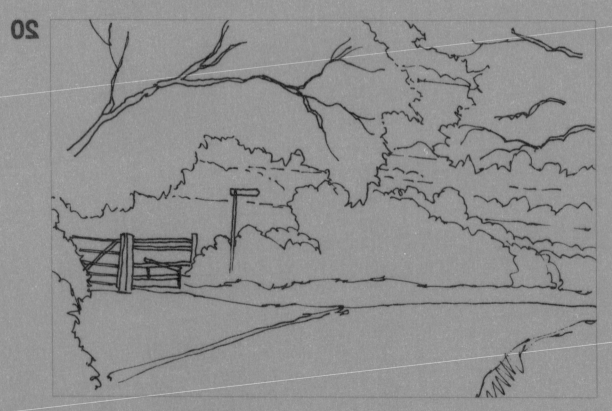

21

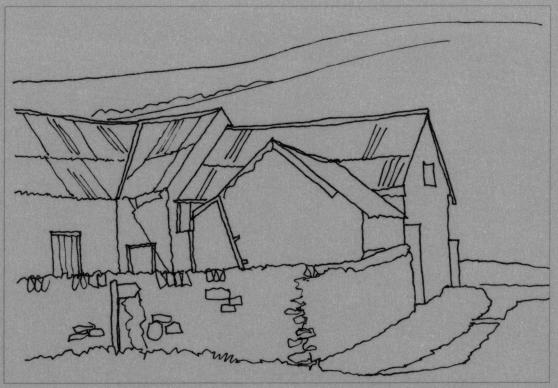

22

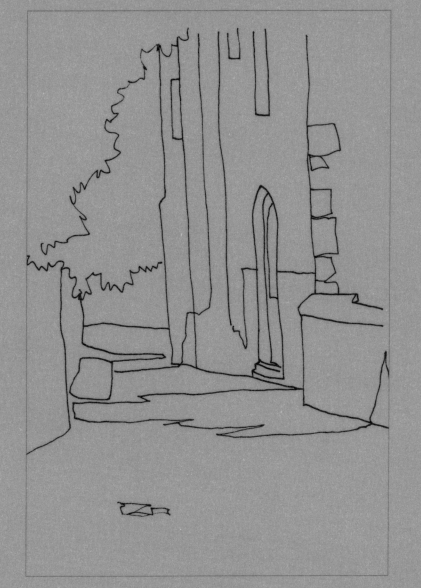

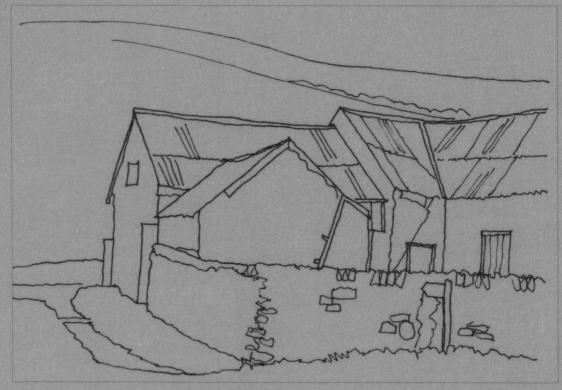

21

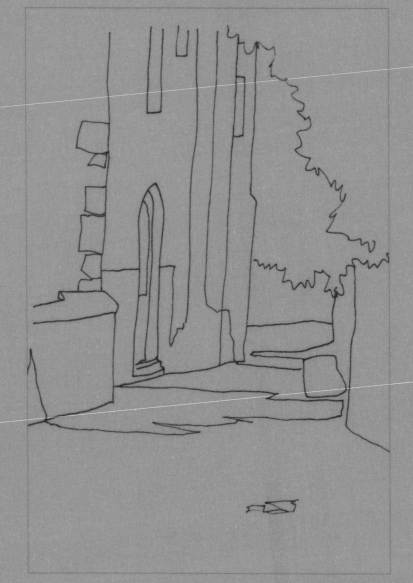

22

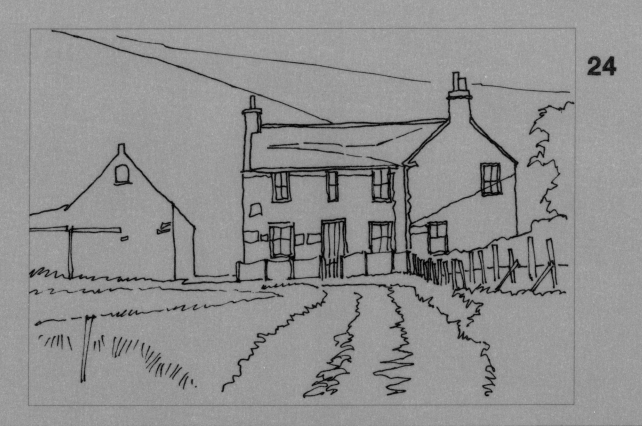

24

23

25

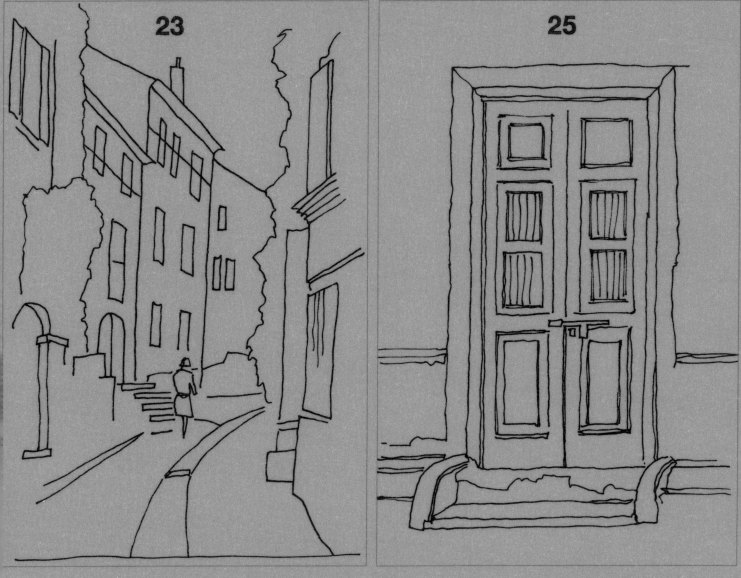

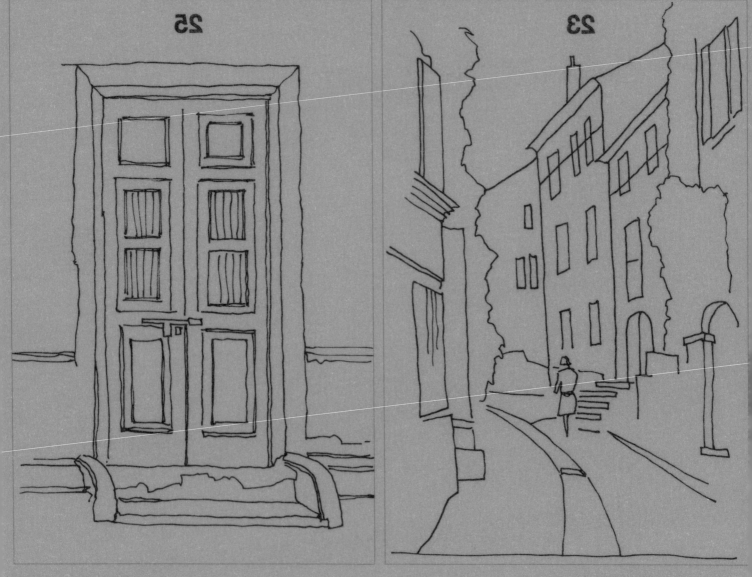

26

27

28

26

27

28

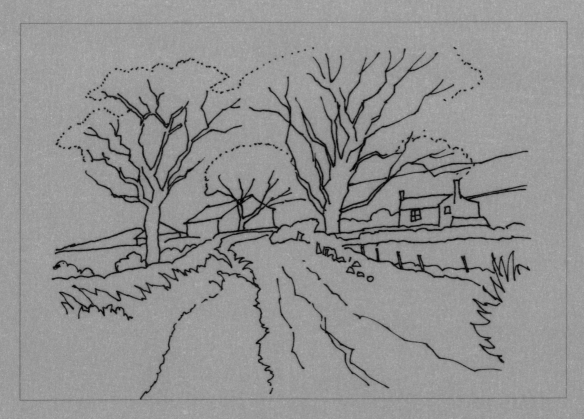

Ready to Paint in **30** Minutes

Landscapes
in Acrylics

Dedication

To Sally, my other half, and our four new *nith*s who are a
constant inspurration – when they are not running riot.

Ready to Paint in **30** Minutes
Landscapes
in Acrylics

Barry Herniman

SEARCH PRESS

First published in 2020

Search Press Limited
Wellwood, North Farm Road,
Tunbridge Wells, Kent TN2 3DR

Reprinted 2021, 2022

Text copyright © Barry Herniman 2020

Photographs by Roddy Paine Photographic Studios

Photographs and design copyright © Search Press Ltd 2020

ISBN: 978-1-78221-676-6

Suppliers
If you have any difficulty obtaining any of the materials and equipment
mentioned in this book, please visit the Search Press website:
www.searchpress.com

Acknowledgements

To Alayne at Francis Iles Artworks who introduced me to the
wonderful world of Schmincke in the first place, all those years
ago. A great big thank you! Also to Anke at Schmincke, who
took me a step further with the introduction of the super
PRIMAcryl acrylics used throughout this book.

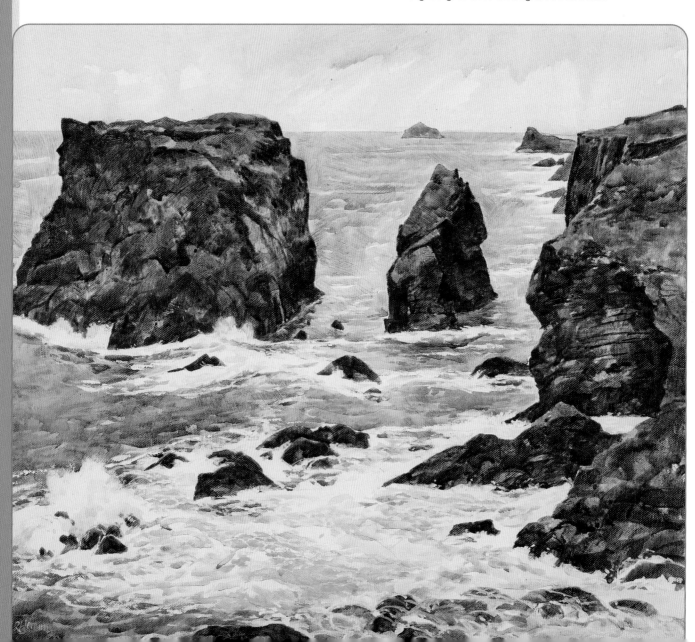

CONTENTS

INTRODUCTION

When I first started my career as a professional artist, I was captivated by the sheer flow and fluidity of watercolours, so that was the path I took for years. I had used acrylics in my previous life as a graphic designer and illustrator, but found the acrylics then available somewhat garish, and with a gooey, sticky feel. When I made inroads into watercolours I gave up on other media and concentrated on getting to grips with watercolours.

However, my outlook on the medium completely changed when a friend gave me some tubes of modern acrylics to try out – what a revelation! Diluting them down with water to a wash consistency, these acrylics were almost indistinguishable from watercolour; the colours remaining rich and vibrant, and the consistency silky and smooth. After further practice, I started to move beyond what can be achieved with watercolour alone, and experimented with different supports – not only watercolour paper, but canvas, MDF and canvas boards – and found some super results. This story gives you the background of my teaching methods: of 'painting acrylics the watercolour way', which I find extremely exciting and make the most of the medium.

This book starts with a selection of different tips and techniques to get you into the swing of using acrylics, before we move on to producing quick postcard-sized studies that show you how to capture different elements of the landscape that surrounds us. Taken in turn, they introduce you to new techniques and painting methods as we go along.

Once you have all this new-found expertise under your belt, we can put it all together to produce larger finished paintings; at the end of the book, I have chosen three very different landscape scenes for you to paint. These will give you a good grounding in pulling it all together to produce finished works of which you will be proud.

Please remember, however, that the exercises in this book are there to give you a flavour of the different aspects of landscape painting, and hopefully impart some of my enthusiasm for this extremely exciting and versatile medium. For that reason, please feel free to deviate and do your own thing at any point along the way. This way you can start to impart your own stamp onto your painting and lay the foundations of your own style.

By the end of the book, you will be able look around you at all the wonderful scenes that abound... and paint them. Enjoy this super medium and don't forget to keep the fun element in your work. Happy painting!

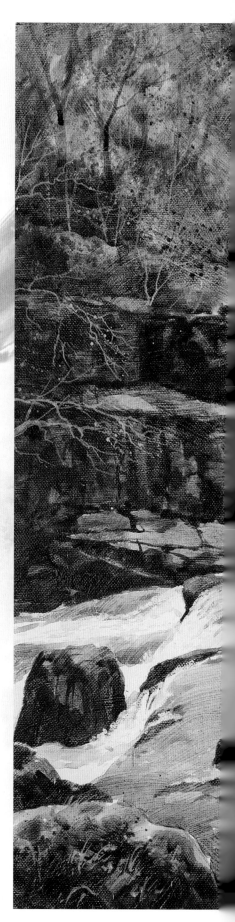

 Below the Falls, Yorkshire

60 x 50cm (23½ x 19¾in)

The first time I visited Aysgarth Falls in Yorkshire, UK, it was mid-summer and the river levels were quite low. Not so when I returned many years later in the spring after some heavy rains – quite a different story!

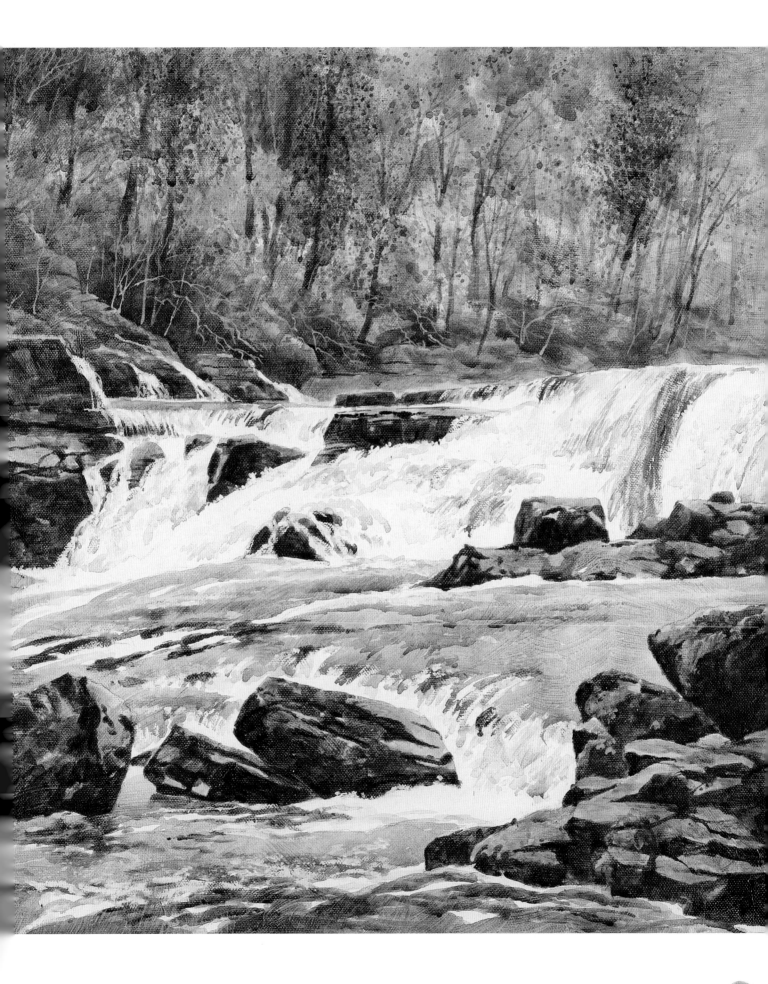

BASIC PAINTING EQUIPMENT

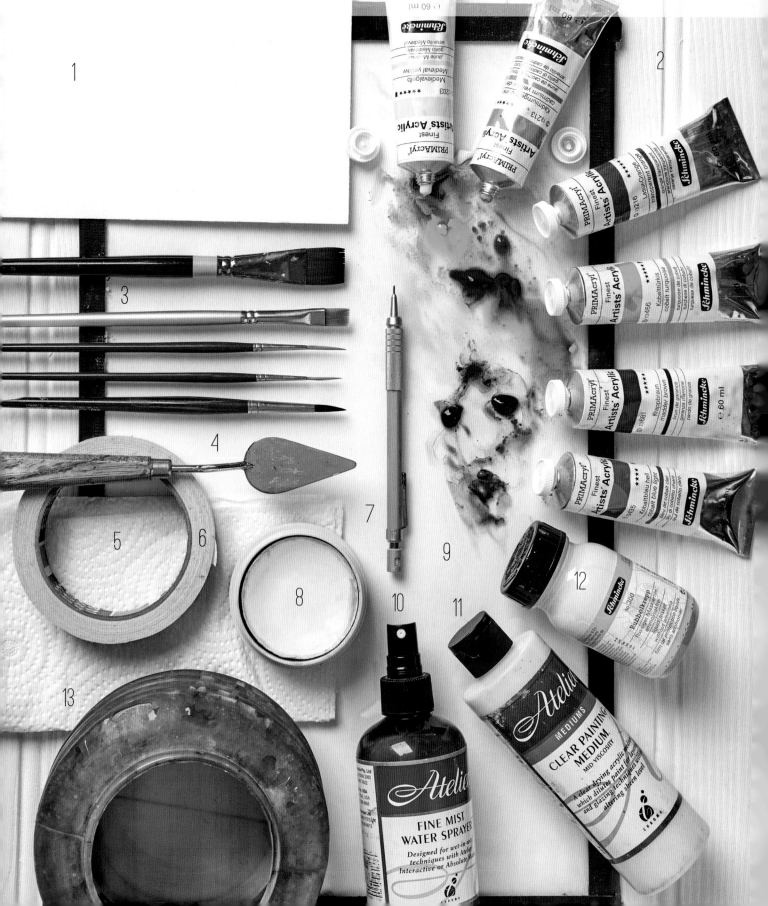

The beauty of this versatile medium is that you don't need a huge array of painting materials to get you started. My suggestions for where to start and personal recommendations are detailed here. If you choose to use different brands, look for similar qualities to ensure best results.

1 Paper Papers come in all different brands, with different weights and surfaces. The weight indicates the thickness of the paper. I prefer to use anything between 300gsm (140lb) and 640gsm (300lb); anything lighter tends to cockle and buckle when wet. The surface texture varies too, from smooth hot-pressed (or HP); through semi-textured Not surface (short for 'not hot-pressed'); and on to heavily-textured Rough surfaces. My preferred brand is Saunders Waterford High White, because it helps give a bright, vivid finish. Hahnemühle Leonardo and Andalucia are excellent high-quality alternatives.

2 Paints The paints that gave me my 'eureka!' moment, described in the introduction, were Interactive Acrylics from Atelier. I also loved using Schmincke Horadam watercolours for years, so I thought I'd give their PRIMAcryl acrylics range a try, and what wonderful paints they were. I now use them almost exclusively and the demonstrations in this book are done with them. They reduce down with water to a lovely watercolour consistency without any loss of colour intensity or adhesion which is great for my 'acrylics the watercolour way' method of painting.

3 Brushes Look in any art materials catalogue and you will be overwhelmed by the wild array of different brushes you can use for acrylic painting, ranging from very cheap to the very expensive. I tend to keep my expensive sable brushes away from my acrylic paintings as they can wear down the points rather dramatically. Instead, I tend to use a combination of acrylic and watercolour brushes depending on the scene I am depicting. I also use both round and flat brushes: the different shapes allow for different techniques. The rounds I use are usually a sable synthetic mix, while the flats range from a smooth to a coarser synthetic.

4 Painting knife A great tool for mixing paint and also for scraping off used and dried-up paint on the palette.

5 Kitchen paper Always handy to have around for cleaning up areas of mixed paint on the palette, kitchen paper can also be used for lifting out areas on a painting and generally keeping the painting area clean.

6 Masking tape This low-tack adhesive tape is handy to have around to fix paper to a board. Sometimes I will run a length of tape round the edges of the painting – when removed after the painting is finished, a nice clean white border remains.

7 Pencil I am a bit heavy-handed with my pencil work, so I tend to use propelling pencils to ensure I can keep a point at the touch of a button.

8 Brush cleaner Brush cleaners are soap and conditioner for your brushes, which are great for cleaning out paint residue from the filaments of your brush. At close of play, draw the damp brush through the cleaner, gently massage the hair, then rinse and reshape. I favour The Masters Brush Cleaner.

9 Palette You can use almost anything as a mixing palette for acrylics. I started painting using a stay-wet palette to keep the paint workable. There are various paper tear-off palettes on the market, which are also fine. I use a glass palette which is great for mixing and easy to clean up afterwards.

10 Water mister spray Keep this handy to periodically spray your paints on the palette and also the painting itself if you wish to keep the paints workable. If you are using Interactive Acrylics, a burst from a water mister will keep the paints moist and workable for ages.

11 Clear painting medium Mixed with the paint, this colourless medium gives the painted area a lovely transparent coating allowing all the underlying colours to shine through. It is a great medium for getting the best out of your glazes.

12 Masking fluid You either love it or loathe it! Masking fluid is a latex-based fluid that is selectively applied to stop paint getting to certain areas of the paper. All too often it is applied in a rather slapdash way and the results can be rather disastrous; but used with a certain amount of care, it can be a great tool to reserve those brilliant whites within a wash area.

13 Water pot You'll need plenty of clean water for the acrylic painting techniques in this book. I use a collapsible plastic pot for ease of transport.

TIPS AND TECHNIQUES

Here we go! In this section we will be getting to grips with acrylics. I will be working through all the basics with you, from which painting methods to use to achieve different effects, to which supports you can use. This will give you a good grounding in how to use this truly versatile and user-friendly medium.

I know you will want to get straight into making pictures like those shown here – I was the same when I started – but time spent honing your painting skills on these basics will really prove beneficial.

Following the series of half-hour exercises throughout the book will let you work through all the different aspects that go into making an enjoyable landscape painting. My advice is to concentrate on building up your confidence with all these preliminary exercises before you take the next step. You can practise and repeat these exercises and so build up your painting skills in your own time and at your own speed.

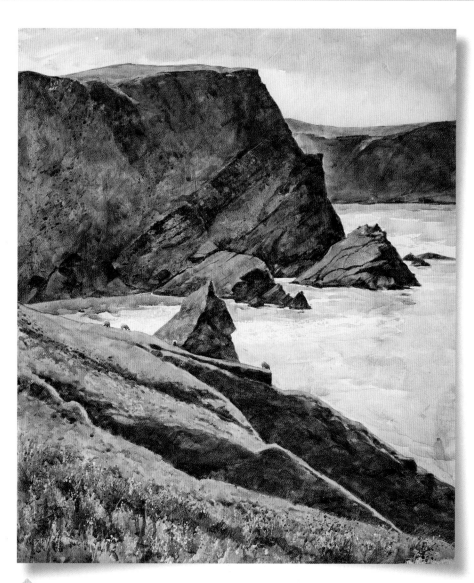

Life on the Edge, Shetlands

50 x 60cm (19¾ x 23½in)

On a trip to the Shetlands, we took the ferry to the northern island of Unst, where we undertook the coastal walk through the Hermaness National Nature Reserve. After getting our photos of Muckle Flugga lighthouse, we made our way back and this was one of the terrific views along the way. The sheep seemed to perch precariously on the cliff edges, hence the painting's title.

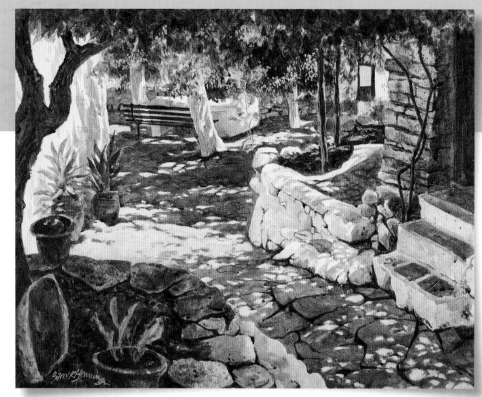

Sunlight and Shadows

50 x 40cm (19¾ x 15¾in)

The array of shadows across this view of the square in the cliff top citadel of Kastro, Skiathos, was captivating.

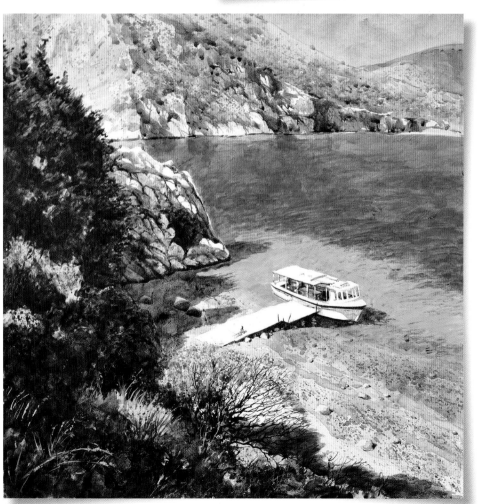

Tolo Island

60 x 60cm (23½ x 23½in)

On a painting trip to Tolo in Greece, I got Georgios to take us for a trip out on his boat. We moored up on this tiny island where we spent a few idyllic hours painting – then had a barbecue lunch to complete the visit.

Preparing and mixing paint

You now have all your materials at the ready... so let's go! Preparing your colour mixes and getting the correct consistencies are very important basic requirements. Time spent on getting this right will pay dividends in your learning process, so have fun and enjoy your colour mixing.

Technique: Pools of colour

I like to work from light to dark, so I start with light mixing colours like yellow.

1. On a clean palette, squeeze out a small blob of each paint you want to use – roughly the amount of toothpaste you'd put on your toothbrush.
2. Dip the brush into clean water, then use the damp brush to pick up a little of the first colour (lemon yellow, here). Place it onto a clean area of the palette and gently smooth it into a pool.
3. Rinse the brush, then repeat with the next colour (in this example, Indian yellow). Place it next to the first pool of colour, slightly overlapping.
4. Repeat with any other colours you want to use – I've used cobalt turquoise, phthalo turquoise and cobalt blue along with my yellows. Note that the mix is not a single uniform hue, but a semi-mixed pool that contains blue-tinged and yellow-tinged greens. It's really important that you do not over-mix your paint!
5. You can add extra colours to the pool as you work – here I'm adding burnt sienna, which adds some warmth, and allows you to create darks with these colours.

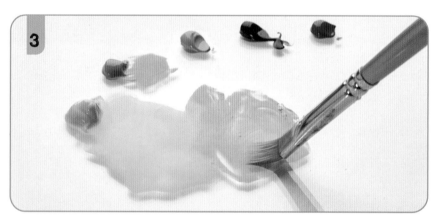

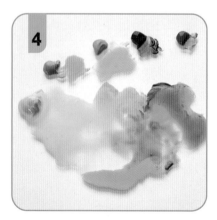

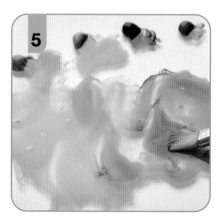

PUTTING IT INTO PRACTICE

Spend your half hour experimenting with mixing colours and doodling on a spare piece of paper. This simple tree is painted with the size 4 flat, using only the colours in the pool.

1 Pick up a little of the lemon yellow and cobalt turquoise mix on your brush and start working into the top of the tree. Take care not to overmix the colours on the paper.

2 While wet, pick up Indian yellow and phthalo turquoise from the pool as you work down into the body of the tree.

3 To get the richer darks in the base of the tree, add just a touch of burnt sienna into the mix and then pull down the two trunks out of this mix.

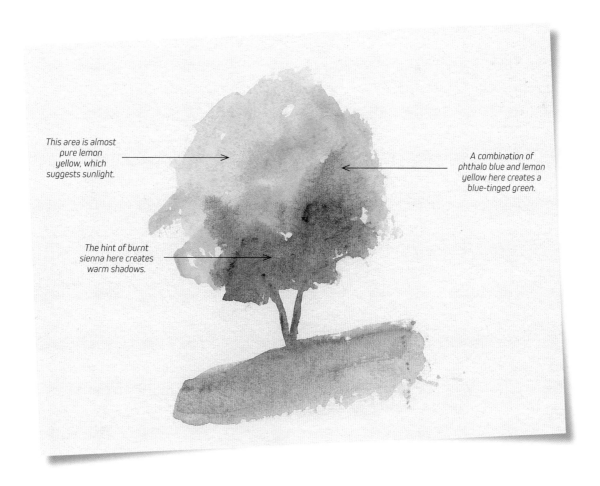

This area is almost pure lemon yellow, which suggests sunlight.

A combination of phthalo blue and lemon yellow here creates a blue-tinged green.

The hint of burnt sienna here creates warm shadows.

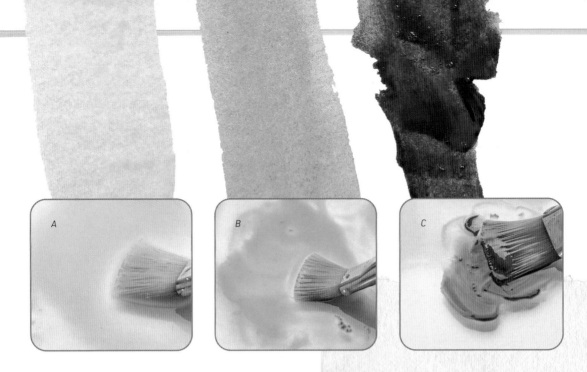

Paint consistency

The amount of water you add will alter the consistency. Above you can see the three main consistencies of paint I typically use. A is watery; B milky; and C creamy.

A: This mix is used when I want the paint to flow especially in skies and water.

B: When I want to get more texture into a passage such as rocks, trees and buildings, I use a milky consistency of paint.

C: A creamy mix is ideal when I want to get more detail into the painting, such as for cracks and crannies in rocks, details in buildings, or branches in trees.

YOU WILL NEED

Paint colours: cobalt blue, transparent violet, lemon yellow, Indian yellow, cobalt turquoise, burnt sienna

Brushes: size 4 flat, size 6 rigger

Other: tracing number 1

Washes

Washes are the staple of your painting repertoire. Getting to grips with the range of tones and effects you can get with the different washes is most important in your learning process. This exercise will show you how to use two key types of wash – flat and graded – in order to paint your first landscape.

The flat wash, as the term implies, is a wash of paint that is even over a whole area. As simple as it may sound, this basic painting technique can often cause frustration in its application. Often, the painter will end up with a rather scratchy and uneven passage which can be a disappointment when starting out. The main reasons for this are not keeping the board at the desired angle; not mixing sufficient wash to cover the whole area in one go; not keeping a 'bead' of colour at the end of each stroke; or simply taking too long between strokes. However, with practice will come confidence!

The graded wash is a different kettle of fish. The basic techniques are the same: keep the board at an angle, mix sufficient paint before you begin and keep a 'bead' of colour moving. The difference is that the paint is graded – either from light to dark or from one colour to another depending on the subject matter.

Technique: **Graded wash**

With a graded wash you can work from either light to dark or dark to light, depending on the effect you want. Here we work from light to dark by adding more paint to an initial watery mix, but you can work the other way by starting off with a stronger mix and adding more water as you go down. Practise and spend some time finding the way you prefer.

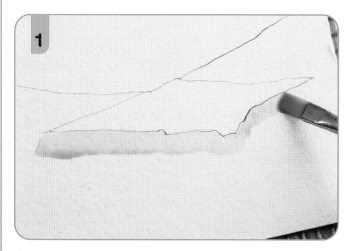

1 Prepare some cobalt blue to a watery consistency. Turn the paper around, so the image is upside-down. Working from the horizon upwards (i.e. down the paper), draw a line across the horizon. Note the bead of paint that forms at the bottom of the brushstroke. We want to keep that moving, or we'll end up with lines.

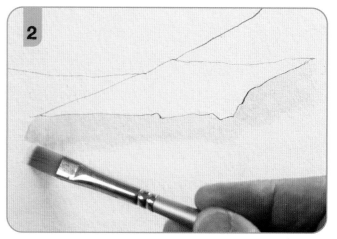

2 When you reach the end of the brushstroke, lift the brush away. Tap the brush into the blob of paint, then into the pool of watery paint and start again on the left, slightly overlapping the first stroke while it is still wet. Pick up the bead of paint and draw it along. Tapping the brush into the blob of paint will strengthen the tone slightly.

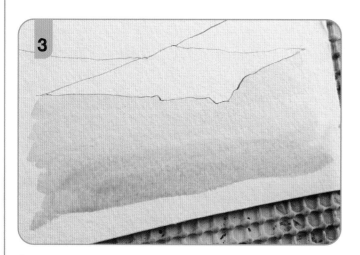

3 Continue this until you have filled the area. Note how the watery consistency on the horizon is paler than the mix at the top of the sky, and how the colour grades smoothly from light to dark.

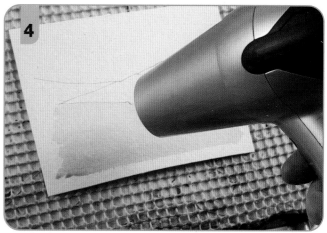

4 Let the wash dry. You can use a hairdryer to speed things along, as acrylics won't shift in colour. Just be aware that if the paint is really wet in consistency, it can get blown about, so wait until the wash has at least started to dry before hurrying things along.

Technique: **Flat wash**

Once the graded wash you used for the sky is dry, it's now time to do some basic flat washes in the landscape. Remember to mix plenty of paint so you don't have to stop mid-painting to mix up more. This will impede the flow and cause all sorts of problems.

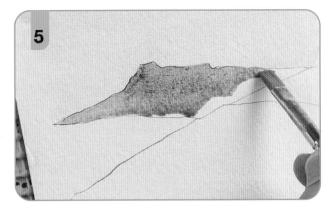

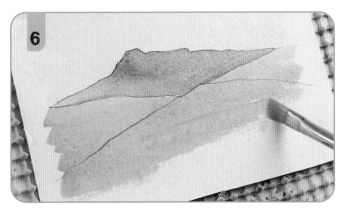

5 Prepare some transparent violet to a watery consistency. Use this to paint the background mountain. As long as the paint is sufficiently wet, you will get a nice flat effect in small areas like this. Allow it to dry.

6 Mix lemon yellow with Indian yellow and cobalt turquoise to make a green pool, and paint the rolling fields. For large flat washes, use long horizontal strokes that pick up the bead of paint in order to get a flat, smooth result. Allow the area to dry.

Keep your paints wet

Once acrylics dry, they become waterproof, and unworkable. Use a fine water mister diffuser to lightly spray the blobs of colour, and pool of colour, and keep your paints workable. Keep an eye on your palette; you'll know they have started to dry because they will feel slightly 'gloopy' and sticky.

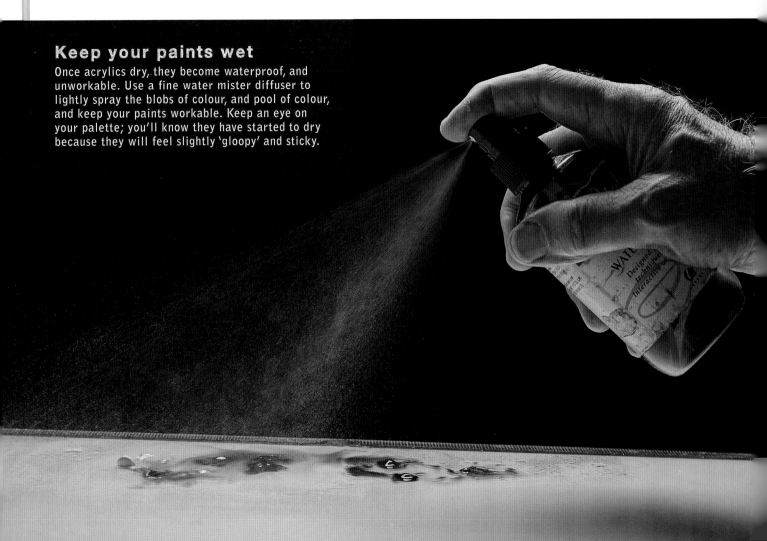

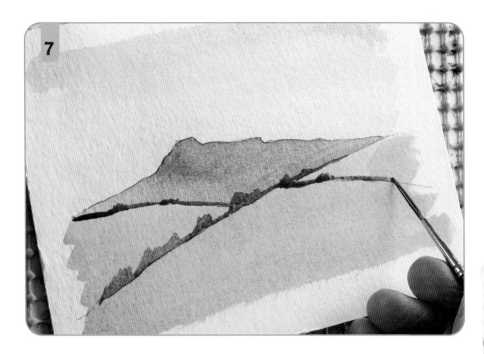

7 Add a little burnt sienna to the mix, then use the rigger to draw along the field boundary lines to suggest some hedgerow trees. This is a small, long-haired brush – originally designed to paint the rigging of boats – that is useful for doing fine lines. You use this brush by pulling it away from you – the bristles then stay together and produce the fine lines you want. As you pull the brush, press down here and there to form hedgerow trees – just be careful to keep them above the boundary line. The thing to remember for hedgerows is ragged tops and smooth bottoms!

Brush care

Make sure paint doesn't dry on your brush – rinse it after applying paint, and leave it in the water. Don't worry, synthetic bristles won't bend in the water pot. Make sure to clean your brushes thoroughly after you finish each painting session.

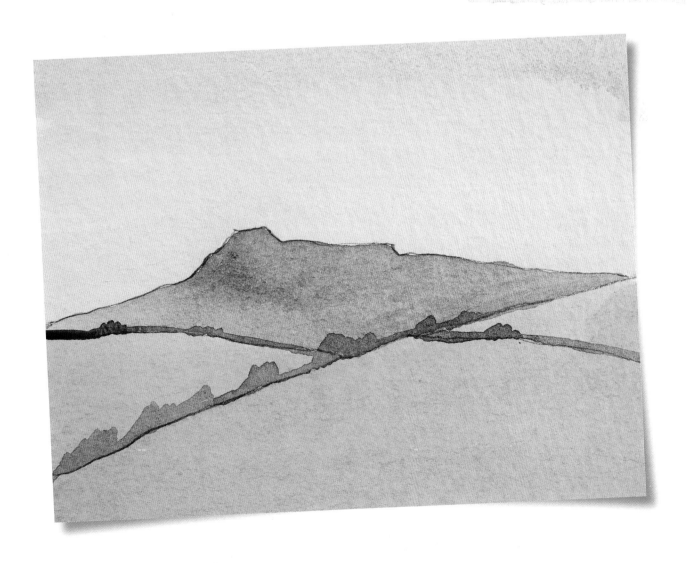

Paint colours: lemon yellow, cobalt blue, phthalo turquoise

Brushes: 16mm (¾in) flat brush

Other: tracing number 2

Simple landscape

Glazing is an essential technique that will let you produce a sense of depth and luminosity in your painting. Here we are putting glazing into practice on a simple landscape just using varying strengths of green.

Technique: **Glazing**

Painting over an already-painted area with a semi-transparent colour is called glazing. Some of the underlying colour shows through, and it is this that creates depth and interest that enables you to look into your colours, rather than at them. Here, we've glazed exactly the same colour over to show you how glazing can be used to build up depth of tone.

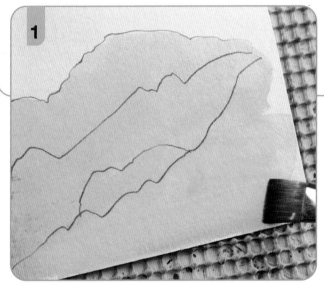

1 Using a 16mm (¾in) flat brush, paint all the hills with a flat wash of green, mixed from lemon yellow and cobalt blue.

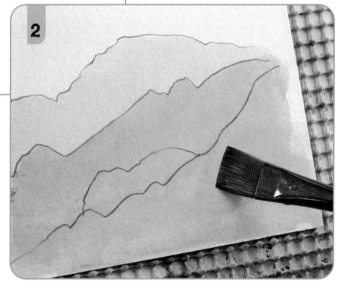

2 The paint must be completely dry before you begin the next stage – the paint is then completely waterproof, so you can safely paint over it. Using the same mix, paint the front three hills only, leaving the topmost one dry.

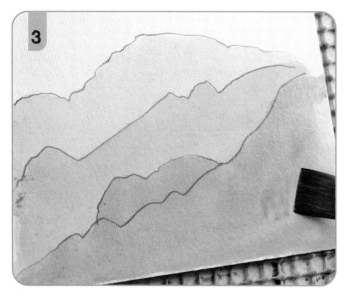

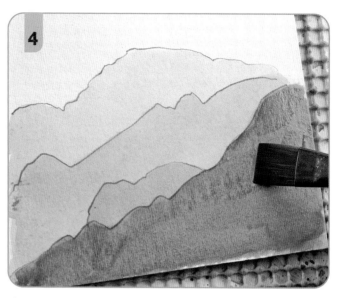

3 Glazing can also be used to alter colour. Once the painting has dried, add some cobalt blue to your mix and glaze just the lower two hills. This builds up the depth of colour without obliterating the underlying green completely.

4 Once dry, add phthalo turquoise to your mix and glaze the lowest hill. A simple wash of blue in the sky and a few marks to suggest stands of trees (made with the size 6 round brush) are all you need to turn this into a simple finished landscape.

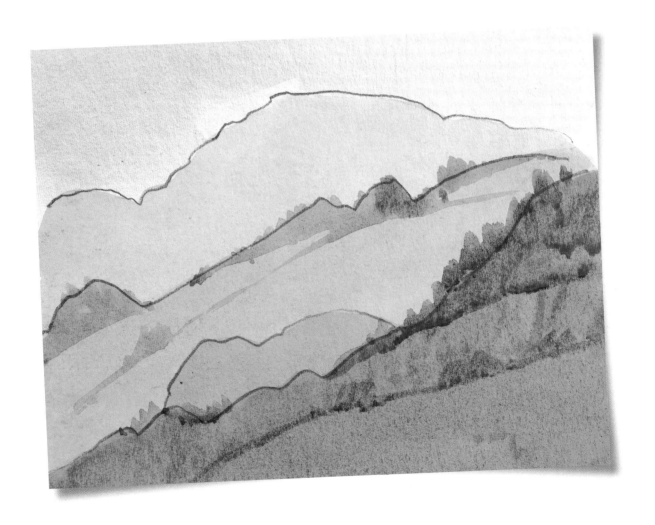

Distant hills

YOU WILL NEED

Paint colours: lemon yellow, cobalt blue, cerulean blue, transparent violet, French ultramarine

Brushes: size 4 flat

Other: tracing number 2

A range of distant hills can be a very emotive subject, and this exercise is a great example of how to use the technique to gain a lovely feeling of depth in your painting.

The same colour is used for all the mountains, but those more distant appear paler and less detailed than those nearer to you, an effect called aerial perspective. This effect is heightened through the impression of low cloud created through a technique called lifting out; and also by building a rocky texture using scumbling.

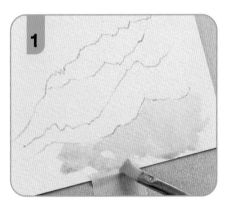
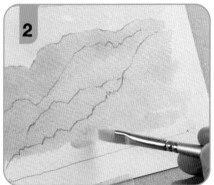
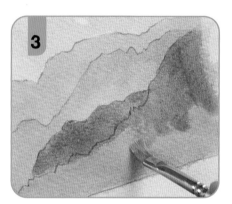
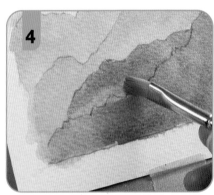
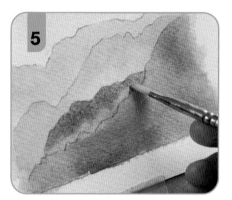

1 Paint the sky with lemon yellow – you may find it helps to turn the painting upside-down, as this allows you to use the shape of the size 4 flat brush's bristles to work around the line of the hill crest. Add cerulean blue wet in wet.

2 Once dry, turn the painting the right way up. Add a touch of cobalt blue to cerulean blue and paint the whole hill area. Allow it to dry completely before continuing.

3 Add a hint of transparent violet to the blue mix and glaze the area from the second hill line down.

4 Before the paint dries, use a clean dry size 4 flat to lift out a little wet paint from above the third hill line. This suggests some light mist or cloud.

5 Once dry, add more transparent violet to the blue mix, and paint from the third hill line down. Again, lift off some paint above the ridge.

Technique: **Lifting out**

Acrylics are waterproof when dry, so once it is dry, you don't have to worry about colour lifting when you paint over the top. While the paint is wet, however, you can add colour to it, or even take it away using a clean dry brush.

6 As you add more paint to the mix – French ultramarine this time – it will start to become thicker in consistency. By the time you reach the final hill line, it will be thick enough to add texture to the foreground. Twist and turn the brush as you work, to catch some areas of the paper, and leave others with the underlying paint showing through.

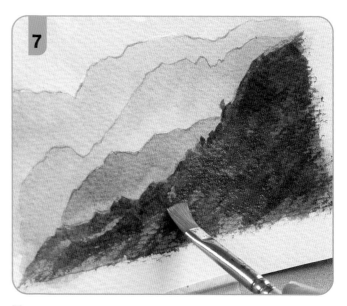

7 Once the painting is dry, dilute the blue mix, and overlay the closest hill with another transparent layer.

Technique: Scumbling

Scumbling is the art of rolling and pressing a paint-loaded brush onto the support. This is also done with thicker, creamier paint where you want maximum texture as with these foreground hills.

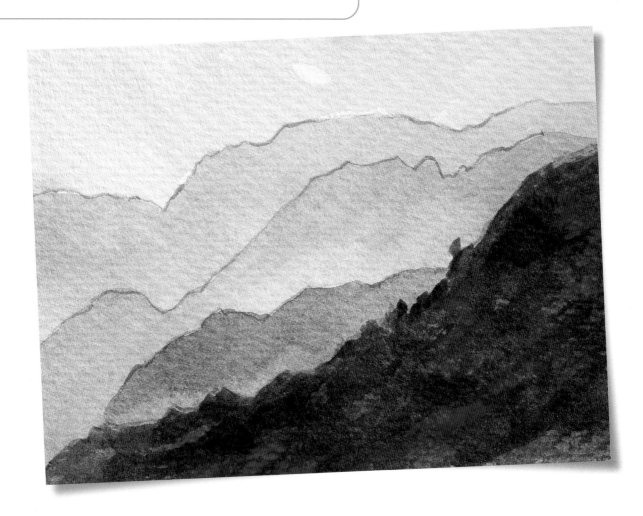

Using different surfaces

So far we have just used watercolour paper, so you'll have got used to the way acrylic paint behaves on this surface. However, one of the things I like about acrylics is that they can be used on multiple different surfaces.

ACRYLICS ON WATERCOLOUR PAPER

There are papers out there specially formulated for acrylics and oils, but I tend to use watercolour papers when I paint acrylics as my painting style means the paint behaves in a similar fashion to watercolours.

Watercolour paper is slightly absorbent, which means that the gelatin sizing provides a little resistance and forces the paint to sit on the surface. Be aware that lighter weight papers will tend to buckle and won't take a lot of rough treatment and scrubbing out.

ACRYLICS ON BOARD

Mountboard, MDF, hardboard – you can use acrylics with almost any rigid surface, as long as you prepare it with a suitable primer such as gesso or acrylic primer (see opposite) before applying the paint.

Once primed, the paint will sit on, rather than soak into, the surface. This brings up new horizons: the way the paint reacts on the surface means that you can get different exciting – and slightly unpredictable – effects.

My preferred board is 4mm (¼in) thick which is quite rigid and does not bend.

ACRYLICS ON CANVAS

I love working with acrylics on stretched canvas as, unlike rigid supports, there is a lovely 'bounce' to the surface. I tend to work on box canvasses, which are usually 38mm (1½in) deep and can be hung directly on the wall without framing. I paint the sides so they match in with the colours of the painting, rather than just leaving the white canvas.

Like board, primed canvas is a non-absorbent, 'slick' surface. The weave of the fabric gives it a distinctive textural surface, which varies by material. Cotton and linen are two of the more popular surfaces but check with your art supplier to see what else is on offer.

Technique: **Priming board**

You apply a primer exactly like paint; but don't use your best brushes. Use an old brush, or a household decorating brush instead. When applying the primer, you can apply it smoothly. However, I like to add some swirls and marks, as shown, to create some readymade texture for my paintings.

PUTTING IT INTO PRACTICE

Practise painting on different surfaces and getting used to how the paint acts on the different surfaces – here's an example of the same painting as the exercise on pages 14–17, painted on canvas board instead.

Canvas board

Canvas board is a cheaper alternative to stretched canvas panels. It retains all the characteristics of canvas but on a rigid support. It is a great introduction into painting onto canvas without breaking the bank.

Misty scene

YOU WILL NEED

Paint colours: Indian yellow, transparent orange, madder brown, transparent violet, cobalt blue, tinting white

Brushes: 16mm (¾in) flat

Other: tracing number 3

Acrylics dry waterproof, so you can't lift out or lighten them once they've dried. However, you can paint over the area to correct any mistakes using either a primer like gesso (see page 25) or titanium white (see page 55), so you can relax; there's no need to feel under pressure.

Sometimes, however, you might simply want to adjust areas, rather than get rid of them completely. In these cases, tinting white – a semi-transparent white – can be used to paint over the area and lighten the tone, knocking the area back rather than obscuring it completely. You can create lovely misty effects by using tinting white, which will allow you to paint fogs or mists over dry acrylics.

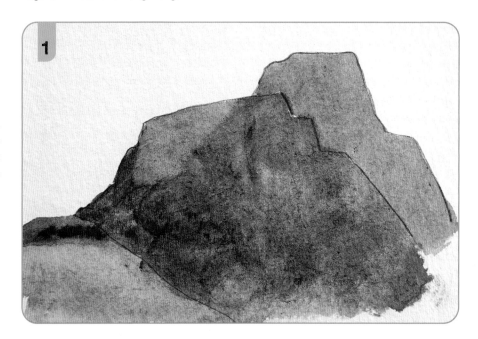

1 Identify the area of your painting where you want to knock back the tone. This rocky landscape was painted with the 16mm (¾in) flat, using the colours listed above.

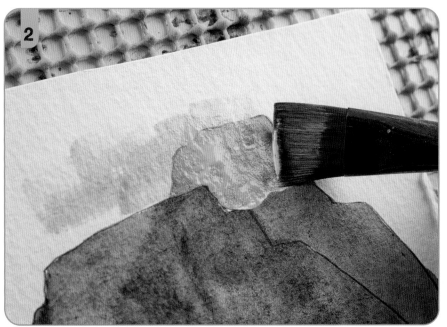

2 The distant hill is quite stark, so I decide to knock it back with a transparent orange and transparent violet mix. Combining these colours makes a neutral grey. Adding a hint of this to tinting white allows me to add mist over the background rocks – you can see how the transparency works here; letting some of the underlying colour show through.

TIPS AND TECHNIQUES

24

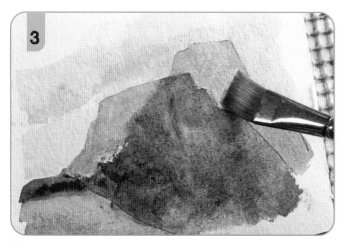

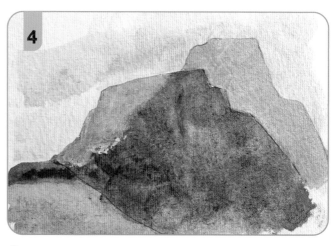

3 You can also combine tinting white with other acrylics. It's not as opaque as titanium white, so it mixes well with other colours. Here I've combined it with burnt sienna to make a soft cloudy effect.

4 Once dry, you can see the overall effect the tinting white has on the underlying paint.

PUTTING IT INTO PRACTICE

The more developed example below was worked on canvas board, using the same techniques and colours as the exercise. Try it yourself to practise using tinting white and canvas board – and to enjoy adding a little more detail to the scene! Just be sure to spend only half an hour – this will help you to avoid overworking it.

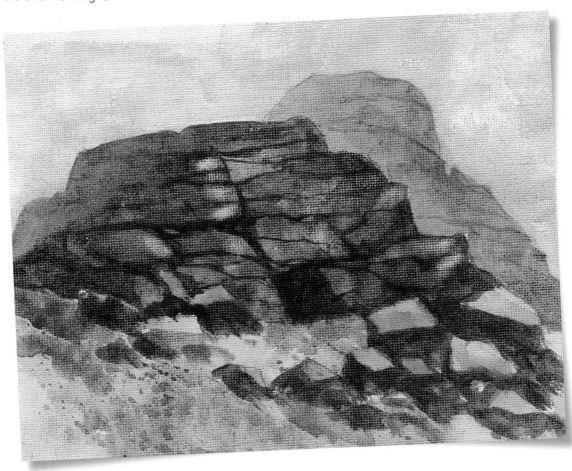

Paint colours: Indian yellow, transparent orange, madder brown, transparent violet, cobalt blue

Brushes: 16mm (¾in) flat, size 6 round

Other: tracing number 4

Rocky outcrop

Creating texture in a painting is a lot of fun and you can end up with some lively and exciting results. One of my favourite ways of producing texture is by spattering paint onto wet or dry surfaces. Watch how the paint spatters are affected differently when on a wet or dry surface.

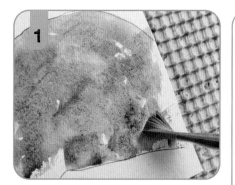

1 Adding texture to paintings can be done in a number of ways. One of the simplest is to twist and turn a flat brush, using short brushstrokes to create an interesting finish.

Technique: **Spattering**

You must have the right flicking brush! Too springy a brush will cause the spatters to go everywhere. The best ones to use are natural hair brushes with not too much spring. Practise with your own brushes and learn how they handle. The larger the brush, the larger the resulting spatters. A too-small brush will barely spatter at all, so find a happy medium between control and effect.

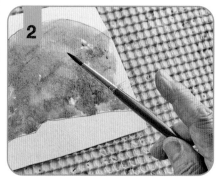

2 While it remains wet, load a brush with watery paint. Hold it a short way above the area you want to spatter.

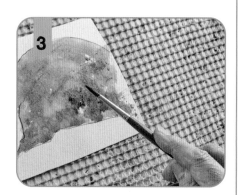

3 Use your finger to tap the handle firmly, to shake a few droplets off into the still-wet surface.

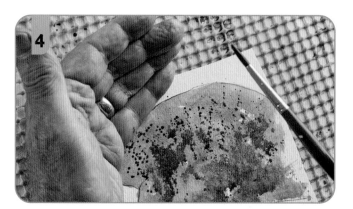

4 You can be more vigorous, shaking the loaded brush at the surface to send a streak of spatters into the painting. Depending on the angle you move the brush at, you can aim these streaks.

Technique: **Guarding**

Use your hand to guard any areas you want to remain clean. You can use a paper mask (or even masking fluid) to do the same thing, but using your hand is quick and easy – it's a natural way to work, and won't break your flow.

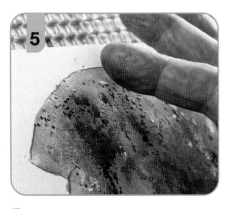

5 To avoid the marks looking contrived, use your finger to lightly tap the surface to join a few of the dots of wet paint together.

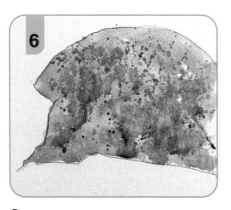

6 You can continue to build up multiple layers of spattering marks in this way, gradually building up texture.

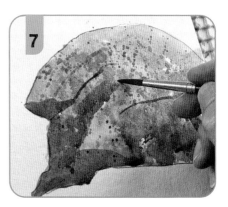

7 Adding these marks early in the process means that they can be incorporated naturally. As you can see here, they show through the shadow glaze laid over the top here.

PUTTING IT INTO PRACTICE

I painted this example onto a canvas board so you could see how the spattering effect works with the surface of the canvas. I have also painted in a summer sky and some foreground foliage to complete the scene – we'll learn the techniques for these in later exercises. You can come back and have another try at a later date; or, if you just can't wait, skip ahead to pages 32–33 for the foliage and 36–37 for the sky!

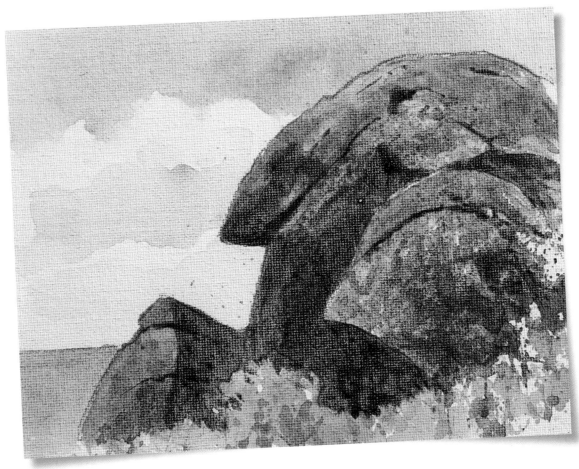

TREES AND SKIES

Having had a go at the basic techniques and got the feel for the medium and which supports you favour, it's now time to move on. We will be concentrating on some of the principal elements that go into a landscape painting: trees and skies, two of the most essential components of the landscape. Skies can be so emotive, setting the whole mood of the painting. It was sorely tempting to fill this whole chapter with skies at different times of the day and at different seasons, but I have restricted myself to a couple of striking, dramatic examples in order to leave space for the equally important trees.

Talking trees: unless you are in a treeless landscape like the Orkney Islands (which I nevertheless love!), you will almost certainly need to put some into your landscape. As with skies, I could quickly fill a whole book and barely scratch the surface of the number of diverse species of tree; so once again I have simplified, and the exercises here concentrate on how trees in the landscape look at different times of year.

 The Road Down to Hilles

76 x 50cm (30 x 19¾in)

When my friend David took me on an autumnal trip around rural Gloucestershire on the edge of the Cotswolds, we came across this rustic track which didn't seem to go anywhere specific. How wrong I was: further exploration brought us to the grandeur of Hilles house – a magnificent Grade II Arts and Crafts building – perched right on the edge of the Cotswold scarp.

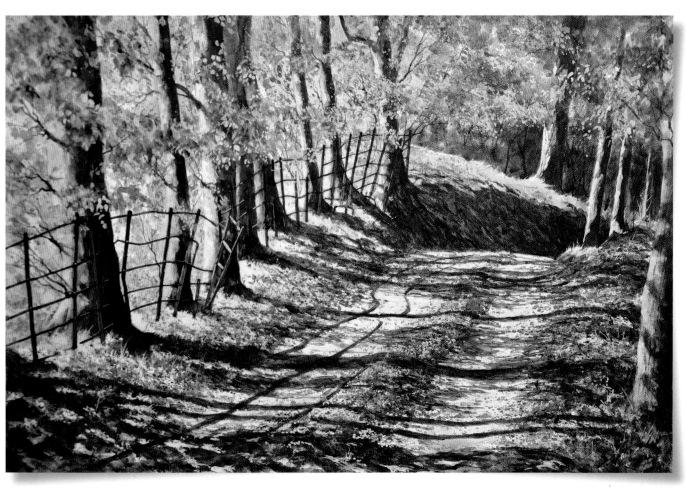

Shetland Sunset

60 x 60cm (23½ x 23½in)

The sunsets on these islands were spectacular
so I obviously had to paint them!

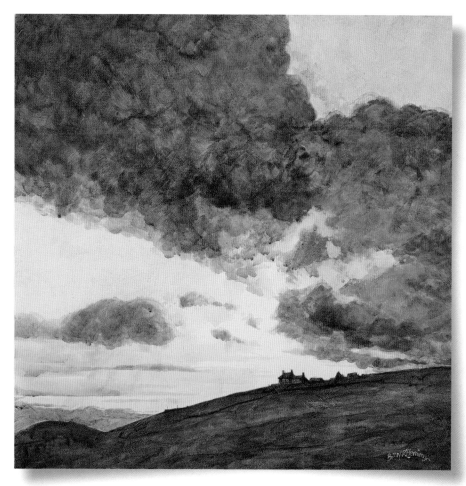

A Break in the Clouds

70 x 60cm (27½ x 23½in)

We were driving down the southern coast of the
Dingle Peninsula in Ireland on an overcast and
stormy day when the sun came bursting through
the clouds, giving me this striking view.

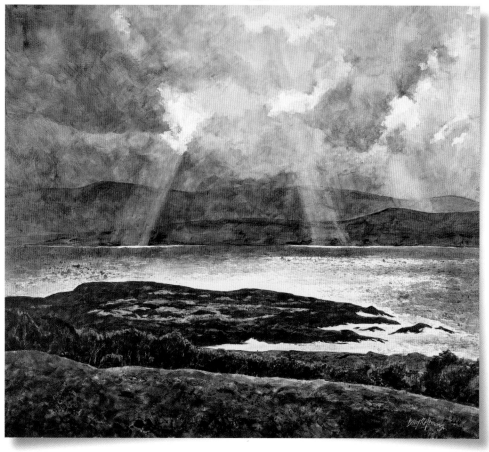

Winter trees

YOU WILL NEED

Paint colours: lemon yellow, Indian yellow, transparent violet, cerulean blue, burnt sienna, French ultramarine

Brushes: size 4 flat, size 6 round, size 6 rigger

Other: tracing number 5

The skeletal outlines of winter trees make for some lovely silhouettes against a bright winter's sky. This makes them a great subject and a chance to get to grips with drawing elements using your rigger, a special long-haired brush designed for drawing long, unbroken lines.

1 Turn the board upside-down. Mix lemon yellow with Indian yellow. Working from the horizon up, begin to paint the trees with the size 4 flat brush.

2 Add hints of transparent violet, then cerulean blue, working wet in wet. Allow to dry.

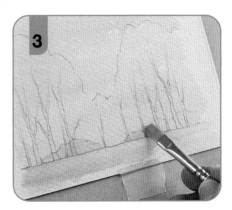

3 Turn the painting the right way up. Add a stroke of dilute cerulean blue across the foreground, then add some hints of blue and purple over the yellow as distant foliage.

Technique: Vibrant darks

Prepare a creamy mix of burnt sienna, French ultramarine and transparent violet. Note that I haven't scrubbed them into submission – there are areas of different colours so that the darks I paint will have different tinges: this adds interest and prevents the darks being all the same.

4 Swap to the size 6 rigger and use the creamy mix to paint the main trunks of the trees. Pull the rigger, drawing the point up from the base of each tree.

5 As the brush starts to run out of paint, use it to draw the branches – the result will be lightly broken strokes, as though the branches are partially hidden behind leaves.

6 Guarding the sky with your hand, spatter the dark mix over the trees with the size 6 round brush, followed by Indian yellow to suggest some remaining leaves.

7 Add some additional branches with the rigger, then paint a dark line across the horizon.

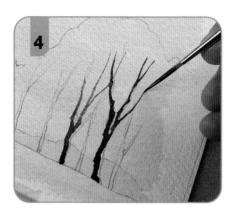
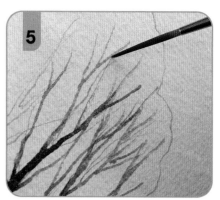
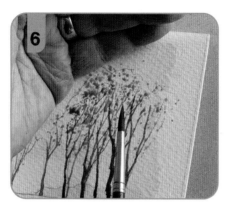
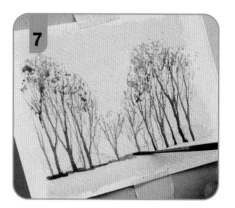

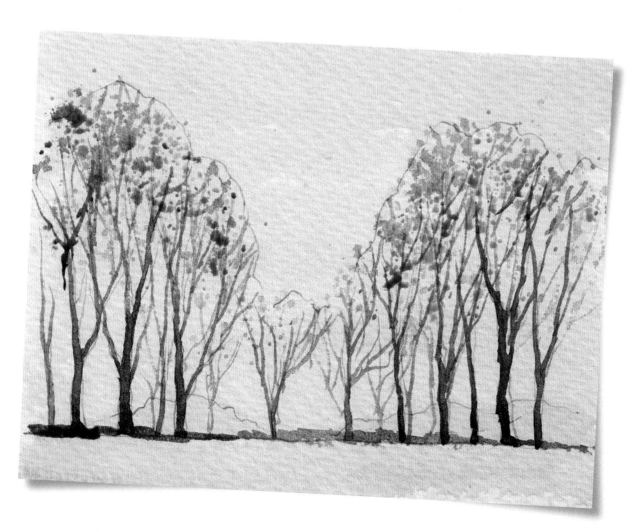

YOU WILL NEED

Paint colours: cobalt turquoise, transparent violet, Indian yellow, lemon yellow, phthalo turquoise, titanium white, burnt sienna

Brushes: size 4 flat, size 6 round, size 6 rigger

Other: tracing number 6

The initial green pool.

1 Paint the sky with dilute cobalt turquoise, using the size 4 flat. Add a little transparent violet and use this to paint the background hills. While you wait for that to dry, spatter the foreground fields with Indian yellow and lemon yellow.

2 Paint in the midground trees using Indian yellow, lemon yellow and a little cobalt turquoise. Avoid making all your greens uniform – vary the proportions to make some areas more blue-tinged; others more yellow-tinged.

3 Twisting the brush to create texture in the undercoat for the large tree, fill in the foliage with a mix of lemon yellow, Indian yellow, phthalo turquoise and cobalt turquoise.

4 Spatter the same mix over the tree, using the size 6 round.

5 Add more yellows into the mix and use smooth strokes to paint the foreground field, then use the bluer parts of the mix to paint the midground ones. Work around the yellow spatters.

6 Add more phthalo turquoise, transparent violet and Indian yellow to the mix and use this to build up strength of tone and suggest form through shadows. The light is on the left, so build up shadows on the right-hand sides of the trees.

Green fields

In addition to showing you how to paint trees in the distance as well as close up, this summery scene is about using different parts of a pool of paint to create an interesting, cohesive scheme. Just like shadows, greens in the landscape are hugely varied, so it's important we don't mix boring, monotone pools. Instead, we lift out our relevant colours from the semi-mixed colour pool on the palette.

Before you begin, make up an initial pool of green with areas of Indian yellow, lemon yellow, cobalt turquoise and phthalo turquoise. Refer to page 12 if you'd like a reminder of preparing pools of paint.

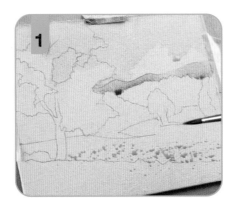

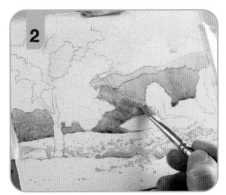

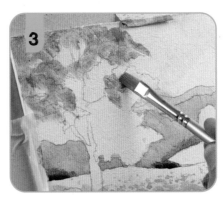

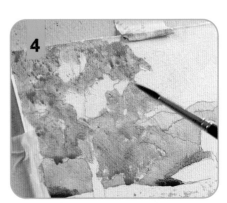

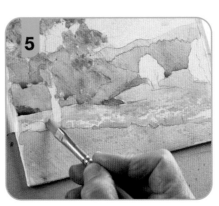

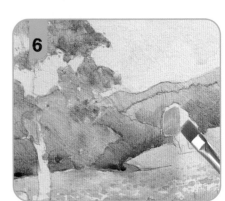

7 Spatter the foreground with more yellow-tinged paint.

8 Build up the dark portion of the mix with the addition of burnt sienna. Use the size 6 round to add cast shadows and create impact.

9 Add the trunk of the tree with the size 6 round, then change to the size 6 rigger for the finer branches. Build up the shadows within the painting with dark portions of the green mix.

10 Spatter titanium white mixed with Indian yellow across the foreground, then add the small tree as a finishing touch.

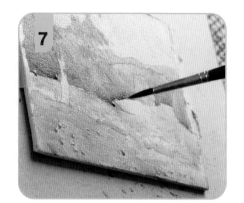
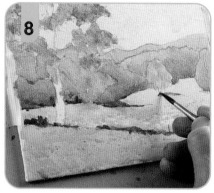
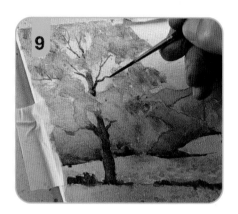
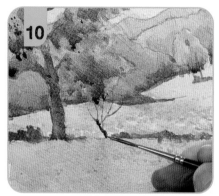

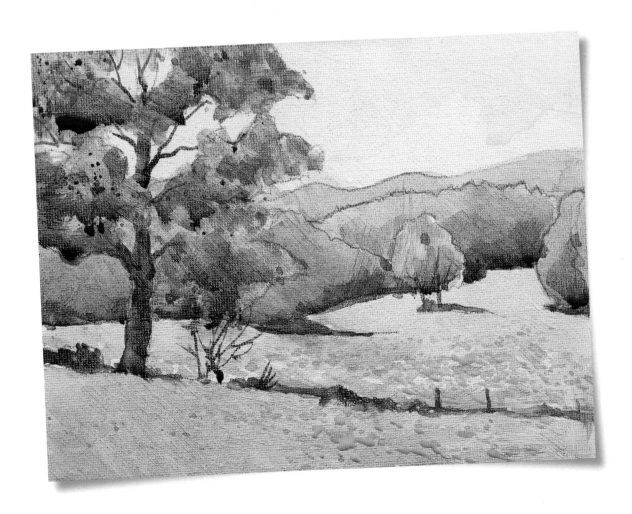

Autumn trees

YOU WILL NEED

Paint colours: transparent orange, quinacridone red, lemon yellow, Indian yellow, transparent violet, phthalo turquoise, French ultramarine, madder brown, burnt sienna

Brushes: size 6 round, size 6 rigger

Other: tracing number 7

Powerful colours give your painting va-va-voom, so it's important to keep them as clean as possible. The techniques we combine here help to ensure the paint hits the surface cleanly, and mixes minimally. Build your colours gradually, with multiple layers.

Technique: **Flick and tickle**

A variation or extension of the spattering technique, this involves using the tip of a fine brush to move the droplets of paint while they remain wet. This allows you more control, and is fantastic for foliage, amongst other things.

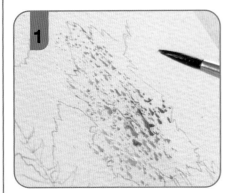

1 Start by spattering lemon yellow into the lightest of the trees using the size 6 round, then add Indian yellow in the same way.

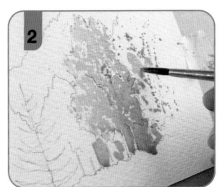

2 Continue to build up with transparent orange, then use the tip of the brush to 'tickle' the wet spots of paint a little to join a few up. Don't get carried away – leave lots of white space.

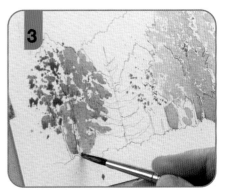

3 Repeat on the left-hand side, using quinacridone red interspersed with Indian yellow for a deeper red tree.

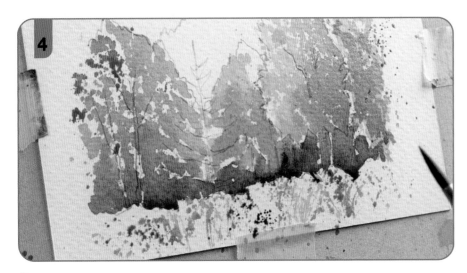

4 While the paint remains wet, add the shadows at the base of the tree line using dilute transparent violet, before building up the foreground foliage with the same technique and the colours remaining on the palette.

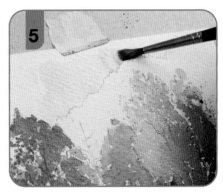

5 Paint in the sky with cerulean blue, then allow to dry.

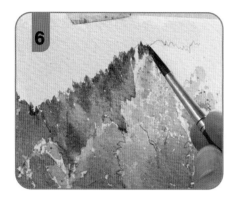

6 Combine phthalo turquoise, transparent violet, French ultramarine and madder brown into a creamy dark blue-green, then paint the distant fir trees with this mix.

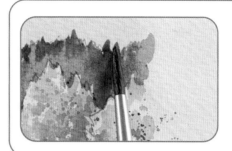

Technique:
Brushtip conifers

Use the shape of the brush to your advantage: hold it so that the tip of the brush forms the top of the tree, and the belly the remainder.

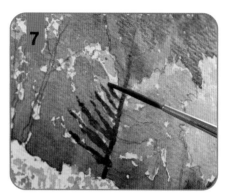

7 Paint the foreground fir trees with the size 6 rigger. Gently push the brush along each line, and roll the handle gently in your hand while you do so. This will help to quickly and easily create naturally off-straight lines.

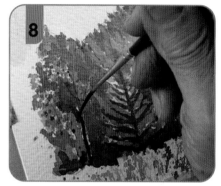

8 Allow the paint to dry completely, then use a dark mix of burnt sienna, French ultramarine and madder brown to add the trunks and main branches of the trees – leave large gaps as shown, so that the foliage appears full.

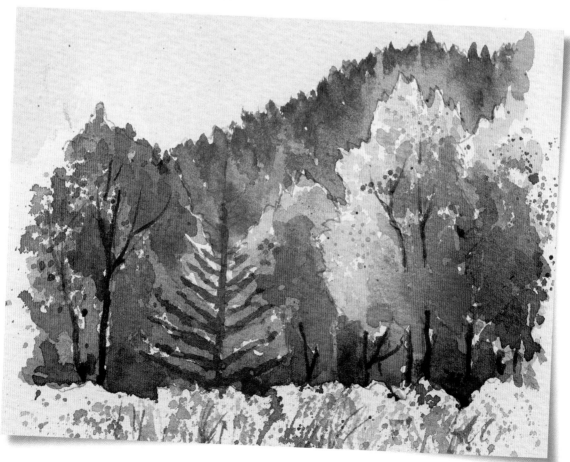

Summer sky

Summer skies are a lovely subject to paint but so many times I have seen students rely on the 'quick fix' method of painting them, i.e. laying down a blue wash, then lifting out the clouds with some tissue. Yuck! In my exercise for you I have deliberately given you a painterly sky with lots of variation in cloud shadow and colour.

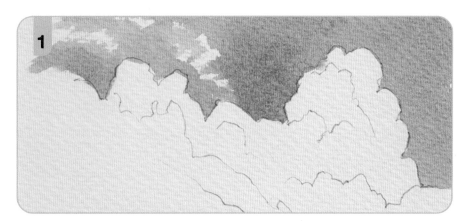

1 Paint the sky area using the size 4 flat brush, and cobalt blue with a hint of French ultramarine added to it. Leave a few gaps as distant clouds.

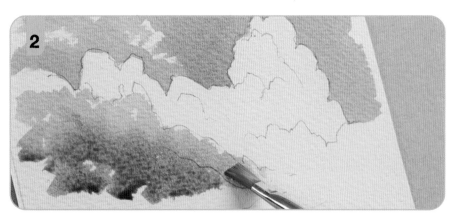

2 Prepare a creamy mix of burnt sienna, transparent violet and cerulean blue. Using a twisting motion of the brush, paint the shadows on the clouds.

3 While wet, add more of the mix at the bottom to darken the shadows.

TREES AND SKIES

36

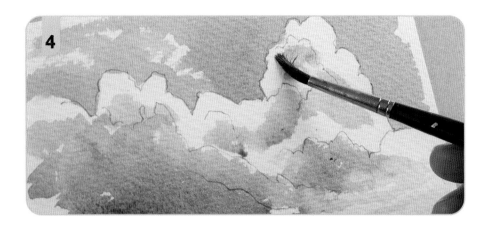

4 Swap to the size 6 round brush and use a more dilute mix to paint the mid-tones. Roll the bristles to create interesting textures.

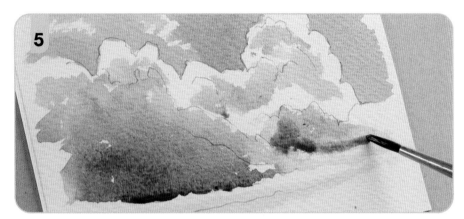

5 Use the tip to develop the shadows wet in wet.

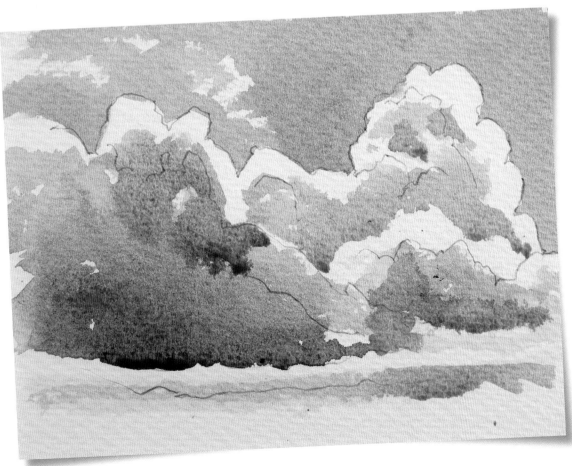

Moody sky

YOU WILL NEED

Paint colours: burnt sienna, Indian yellow, cerulean blue

Brushes: size 4 flat, size 4 rigger

Other: tracing number 9

A moody sky is a scene which allows you to really get to grips with some lovely cloud textures and colours. Remember to keep your colours nice and fluid, so they float around on the surface and mix gently into one another. This will keep any hard edges to a minimum.

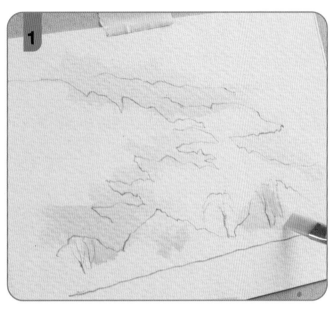

1 Create a sense of light with dilute Indian yellow, tinging the sky around a clean area of white paper.

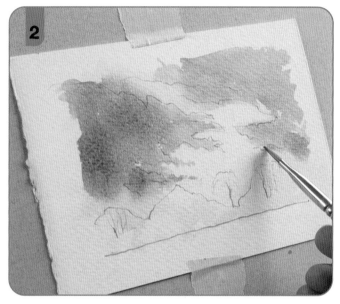

2 Add burnt sienna and hints of cerulean blue to the Indian yellow on the palette, dilute again, and work the mix in wet in wet to build up the clouds. If areas start to dry, add dilute Indian yellow first, then work in the darker mix.

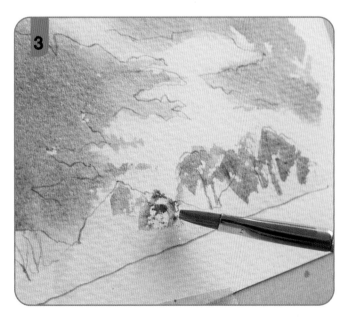

3 Use light strokes to suggest tree foliage at the bottom, using the same darker mix. Use the flat tip of the brush to create trunks and branches with dabbing touches.

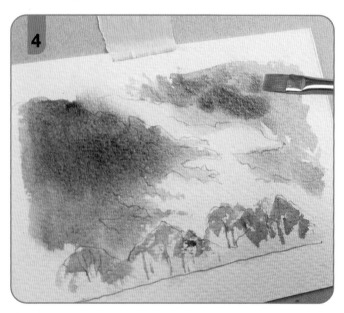

4 Return to the sky to build up the tone with the dilute dark mix.

TREES AND SKIES

38

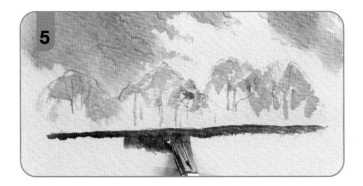

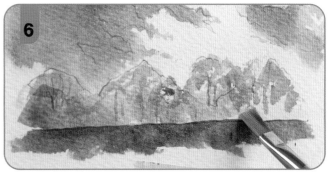

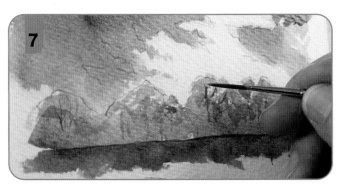

5 Build up the consistency of the mix with more paint, and paint the ground.

6 Dilute the mix once more and glaze the tree area.

7 Add some final touches with the rigger, adding dark marks for more tree trunks and branches.

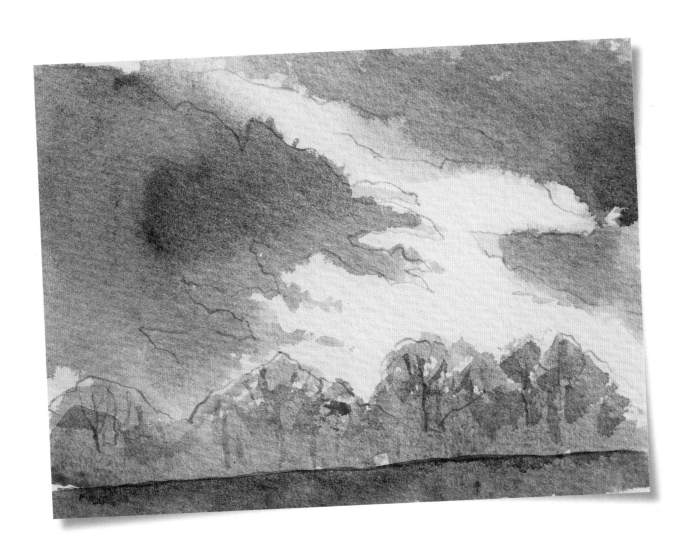

LAKES AND RIVERS

What a wonderfully emotive subject fresh water is. Whether a small meandering stream, a raging river or an expansive lake, there is something about water that makes a scene entirely captivating. However, although water can be such a wonderful subject, painting it can be fraught with difficulty. If the water is too dry and static, the result loses all its fluidity and appears immobile. Fortunately, painting water the 'watercolour way' will help you get that glorious flow into your scene; you can then build up the reflections which will also help enhance the depth in the area. I have also included a few structures associated with water scenes; namely bridges and stepping stones, which can be appealing subjects in their own right.

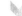 *So Cool, So Clear*

61 x 51cm (24 x 20in)

The small medieval village of Fontaine-de-Vaucluse is tucked in a closed valley up in the mountains of southern France. The Sorgue River begins its life above ground here, rising from the depths beneath a high cliff before flowing down to the village and beyond. The cool, crystal-clear waters give the area a feeling of serenity and calm on a hot day.

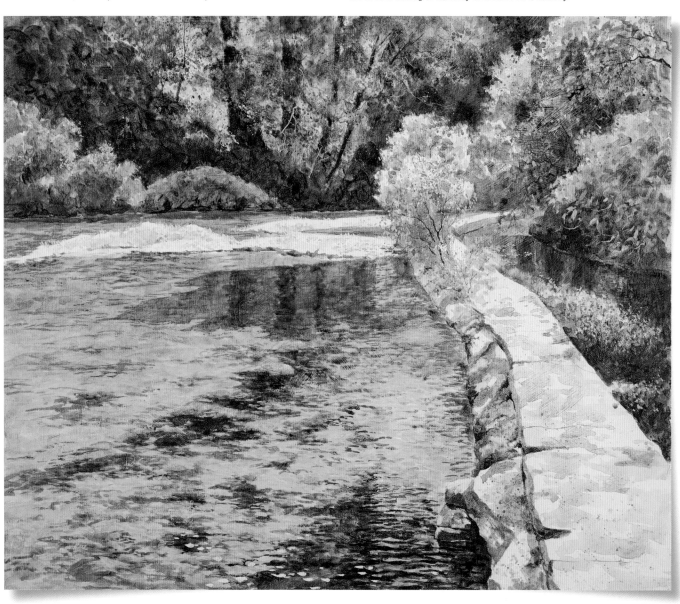

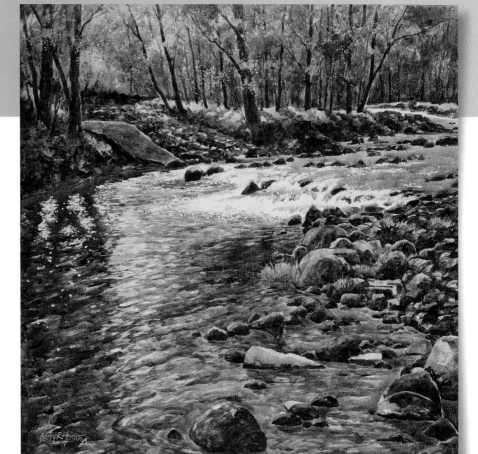

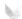 *The Crossing*

60 x 60cm (23½ x 23½in)

This spot, on a shallow beck on the North Yorkshire Moors, was where vehicles crossed and it was just catching the afternoon light. I just loved the simplicity of the scene. In fact, I liked it so much that I later painted a larger square canvas of this scene as a present for my sister and her husband.

In Full Flow

60 x 50cm (23½ x 19¾in)

On this visit to the Aysgarth Falls in Yorkshire, they really were in full flow and very impressive. This is the view of the main falls a short walk up the river valley.

YOU WILL NEED

Paint colours: Mars violet, burnt sienna, cobalt blue, cerulean blue, Indian yellow, transparent violet, phthalo turquoise, lemon yellow, French ultramarine

Brushes: size 4 flat, size 6 round, size 4 rigger

Other: tracing number 10

Flowing stream

Water always makes for a rather emotive subject to paint, and never more so than when it's moving. Even a modest woodland stream can provide an impressive subject to paint, as it meanders through the valley, bubbling over rocks and boulders.

1 Combine Mars violet with burnt sienna, cobalt blue and cerulean blue to make a dark mix, and use it to paint the background a dark tone with the size 4 flat. Add hints of Indian yellow wet in wet to vary the foliage. Rinse the brush, then pick up a dilute mix of cobalt blue with a little burnt sienna. Use the edge of the brush as shown to paint the distant water with fine horizontal marks.

2 Swap to a size 6 round brush and draw the colour down to suggest the shape of the falls.

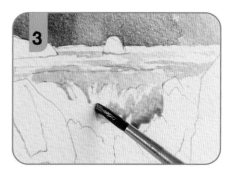

3 Leave a gap of clean white paper – this is the sheen of light reflecting from the falls here – then use a slightly diluted dark mix to suggest the stones beneath the water.

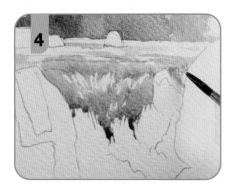

4 Draw the marks together, suggesting the shape and direction of flow. Allow the blue and dark mixes to touch and blend together for soft edges.

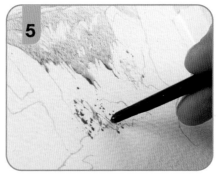

5 Use the blue mix (see step 1) to flick some paint onto the foreground water, then use the back of the brush to tickle the marks together.

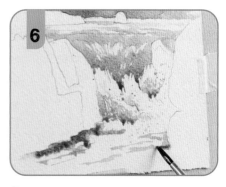

6 Leaving a lot of clean white paper for the foaming water, use the tip of the brush to describe some darker areas in the foreground with wavering strokes.

> **Technique:**
> ## Using the back of the brush
> I have sharpened the end of the brush handle to serve like a pen nib, letting me draw very fine branches and similar with wet spots of paint on the brush.

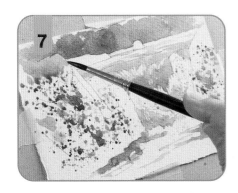

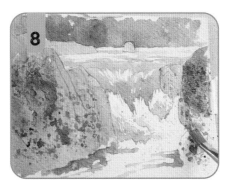

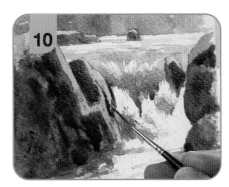

7 Add texture to the rocks by spattering the dark mix over them. Use your finger to knock a few spots together here and there. While the marks dry, paint the grass with phthalo turquoise, adding lemon yellow wet in wet.

8 Once dry, make a dilute mix of burnt sienna and Indian yellow, and use the size 4 flat to glaze the rocky areas. This works as a unifying wash, bringing together the spots on the surface. Add Mars violet to make a slightly darker mix for the right-hand side.

9 Once dry, make a strong dark mix of Mars violet, transparent violet and French ultramarine. Use this with the size 4 flat to build up the tone over the rocks. Vary the hue with cobalt blue and adding more Mars violet and transparent violet. Make the tone particularly dark near the water's edge.

10 Use the rigger to make some final upright marks on the rocks, and the size 6 round to darken and spatter the rocks in the water for some movement and excitement.

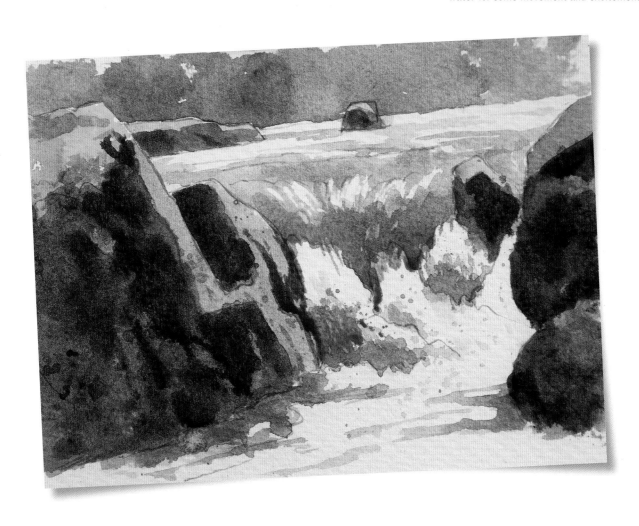

Bridge

YOU WILL NEED

Paint colours: lemon yellow, madder brown, burnt sienna, transparent violet, cobalt blue, French ultramarine

Brushes: size 4 flat, size 6 round, size 6 rigger

Other: tracing number 11

Bridges come in all shapes and sizes and are made from an array of different building materials. They can make a really striking central point of interest or used to add a little detail to a wide open scene. The stone bridge I have chosen for you has some lovely textures in the stonework and some dominant shadows under the arches.

1 Use a creamy mix of lemon yellow, madder brown and burnt sienna to paint the background foliage. Apply the paint decisively using an almost dry size 6 flat brush, to create a choppy, interesting texture. While it remains wet, spatter a wetter mix of the same colours on top, using the size 6 round.

2 Use the same approach to paint the foliage under the arches and the tree on the right.

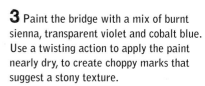

3 Paint the bridge with a mix of burnt sienna, transparent violet and cobalt blue. Use a twisting action to apply the paint nearly dry, to create choppy marks that suggest a stony texture.

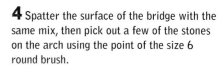

4 Spatter the surface of the bridge with the same mix, then pick out a few of the stones on the arch using the point of the size 6 round brush.

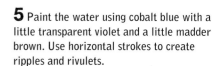

5 Paint the water using cobalt blue with a little transparent violet and a little madder brown. Use horizontal strokes to create ripples and rivulets.

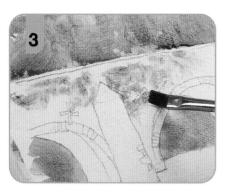

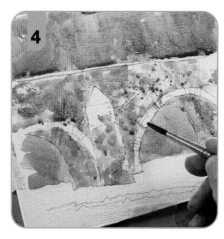

Technique:
Choppy strokes
Press the bristles of a fully loaded brush onto the surface, then twist the handle to produce some random texture.

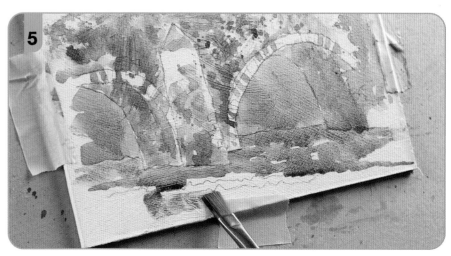

6 Glaze the shaded underside of the arch with dilute French ultramarine, then extend the cast shadow onto the river with broken marks before adding some shadow on the bridge's central support.

7 Swap to the size 6 round to 'tick in' details elsewhere on the bridge.

8 Use the size 4 flat to glaze over the shadow areas, using the edge of the brush to add some loose reflections on the water.

9 Change to the size 6 rigger to paint the steel reinforcing rods with madder brown.

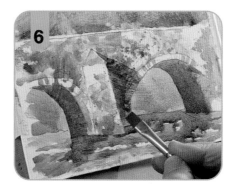
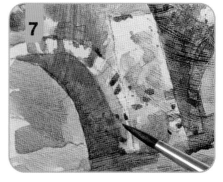
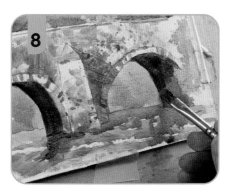
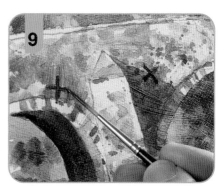
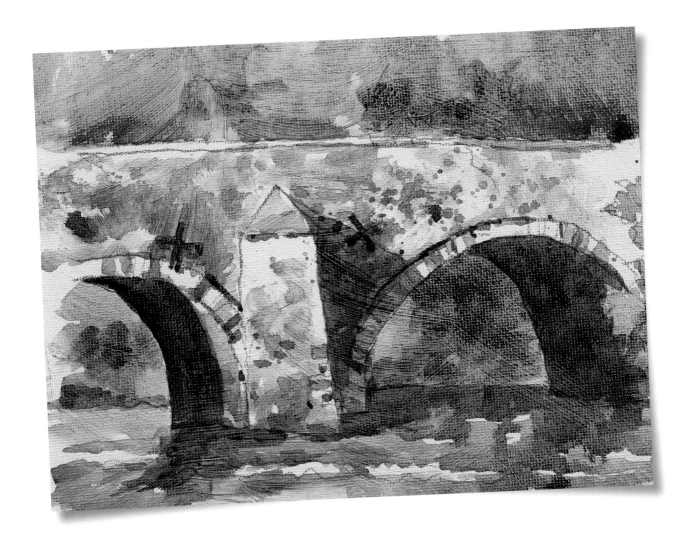

YOU WILL NEED

Paint colours: lemon yellow, Indian yellow, madder brown, cobalt turquoise, burnt sienna, transparent violet, transparent orange, titanium white

Brushes: size 4 flat, size 6 rigger

Other: tracing number 12

Quiet reflections

The challenge in creating effective reflections is in applying the paint as wet as possible without it dripping, then allowing it to dry before repeating the process. In this way, you build up strength of tone and colour while keeping the edges dreamy and soft, achieving a painterly effect both above and below the waterline.

To help with the flow, we're using canvas board so the colours will run easily – the challenge here is to find the right consistency (only slightly diluted) to help ensure they flow but do not drip.

1 Use the size 4 flat to paint the trees using various watery combinations of lemon yellow, Indian yellow, madder brown, phthalo turquoise, and a little transparent violet. Use cobalt turquoise with the tiniest addition of burnt sienna for the rocks. Next, use the flat edge of the brush to apply madder brown along the waterline, to create a definite break between land and water.

2 Allow the painting to dry, then build up the strength of the colours above the waterline using creamier version of the same mixes. Dilute the mixes and add further texture with a little bit of flick and tickle.

3 Once dry, add some warm spots with transparent orange, then begin to build up the reflections in a similar order. Use fairly dilute colours to apply the main shapes, then use a clean damp brush to encourage them to merge and blend on the surface. Allow to dry completely before continuing.

4 Strengthen the tone of the reflections by overlaying more paint. This should be milky in consistency; neither as dilute as water, nor as stiff as cream.

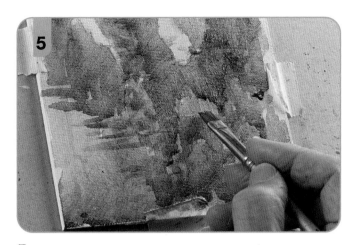

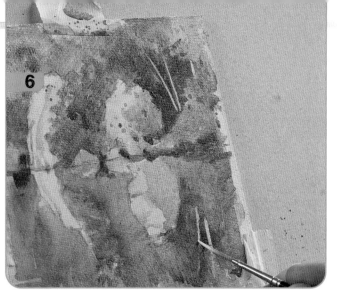

5 Add a few loosely wavering horizontal strokes with the edge of the brush, to suggest ripples and movement on the water's surface.

6 Use the size 6 rigger to draw some light trunks using titanium white. The reflections should mirror the angles of the trees themselves, but add a little waver to your stroke when painting the reflections to suggest water movement.

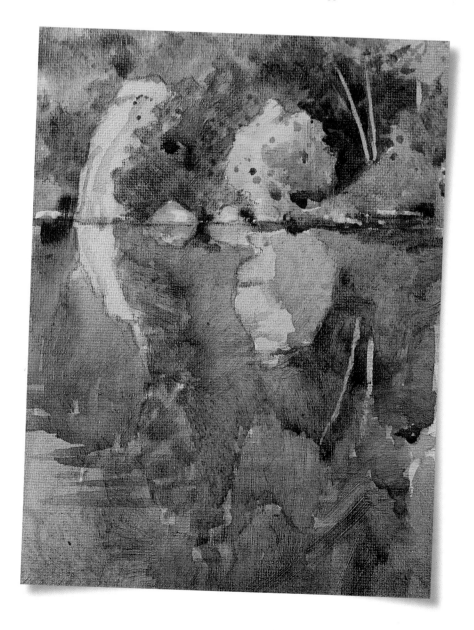

Paint colours: lemon yellow, Indian yellow, burnt sienna, phthalo blue, cobalt blue, French ultramarine, titanium white

Brushes: size 4 flat, size 6 round

Other: tracing number 13

Stepping stones

With this exercise we combine the fluidity of the water with the harder textures in the stepping stones into one scene.

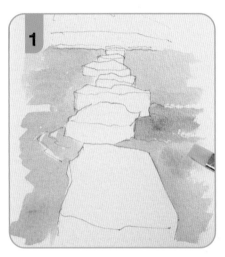

1 Paint an undercoat on the water, using the size 4 flat brush and a green mix of phthalo blue and lemon yellow. Start at the horizon and add cobalt blue to the mix as you work down. Work quickly to build a basis – you can always adjust colours later.

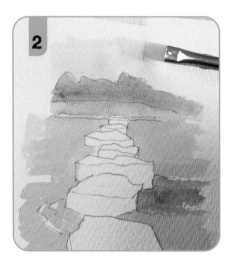

2 Paint the background foliage with Indian yellow, introducing phthalo blue wet in wet at the top. Use very dilute cobalt blue for the sky.

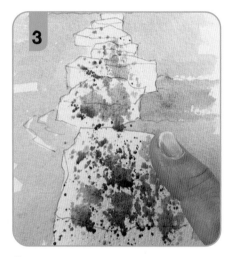

3 Mix burnt sienna and cobalt blue together, then dilute. Flick the colour over the stepping stones from the size 6 round, then lightly tap the tip of your finger to blend the spots together here and there.

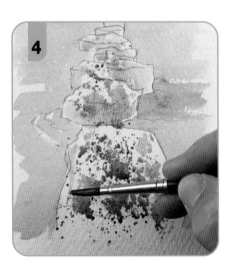

4 Use the brush to draw the colour together in the shaded areas before allowing the painting to dry completely.

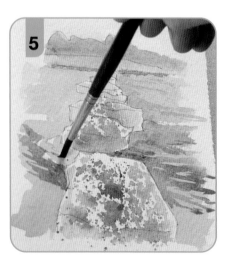

5 Use the tip of the size 6 round brush to draw loosely horizontal ripples on the water to the right of the stones. Add burnt sienna to the mix and do the same on the left.

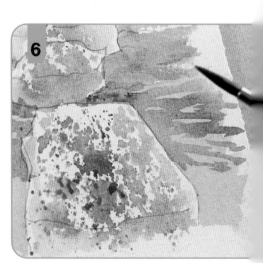

6 Spatter the stones with the mix.

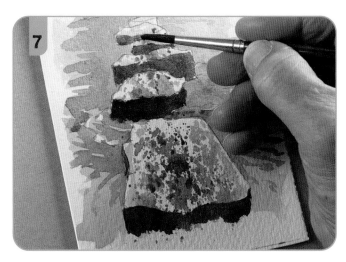

7 Make a dark mix of burnt sienna, French ultramarine and cobalt blue, preparing it to the consistency of cream. Build up the darks over the dry surface.

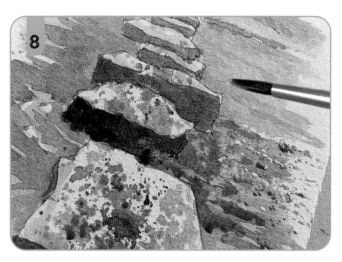

8 Use titanium white to spatter some final highlights onto the water.

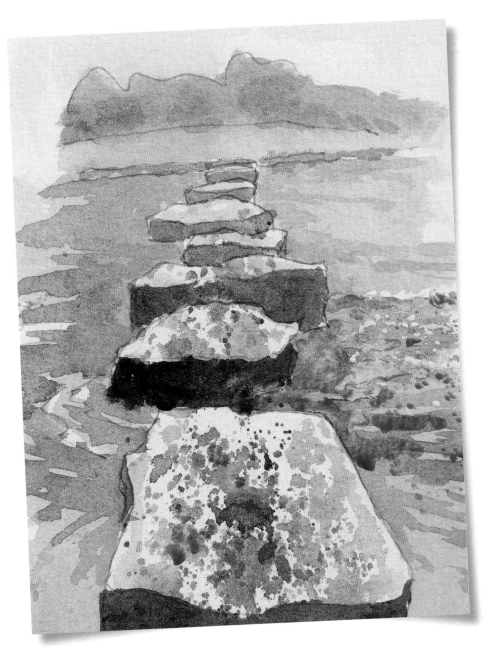

COASTLINES

Onwards and upwards! Now we are moving on to more complex subjects; though rest assured we are still working within the half-hour time frame and postcard-sized paintings. Painting these landscapes will have you progressing steadily and building up your confidence to tackle the forthcoming exercises.

I just love including the sea in my landscapes. Regardless of whether the weather is calm or stormy, the results can be really powerful: blinding light bouncing off the water, huge sea swells in all their foaming intensity, and of course the stormy sea in all its powerful glory.

I have travelled up and down the fabulous UK coastline, from Cornwall and Devon in the south to the Outer Hebrides, Orkney Islands, and Shetland in the far north. Along the way I have witnessed some awesome sea cliffs, stacks and rock formations. One of my best experiences of a sea in full force was at Yesnaby cliffs on the west coast of the Orkneys. Standing atop the sea cliffs, I could literally feel them shudder when the waves broke against them and sent spray up and over. That was something that I wanted to try and convey in my paintings of the place.

Also in this chapter are boats – and whenever I mention boats to my students, I get all manner of weird and wonderful responses. One lady memorably, simply, and categorically announced, 'I don't do boats!', so that was a non-starter for her, but I hope you'll give these rewarding subjects the chance they deserve. The tracings are ready and waiting, so you can once again concentrate on the painting and not worry about your drawing.

Liquid Turquoise, Skiathos

55 x 60cm (21½ x 23½in)

Looking down from the ancient citadel of Castro on the lovely island of Skiathos, Greece, I caught this view of the boat floating in a sea of transparent turquoise. I just had to paint it.

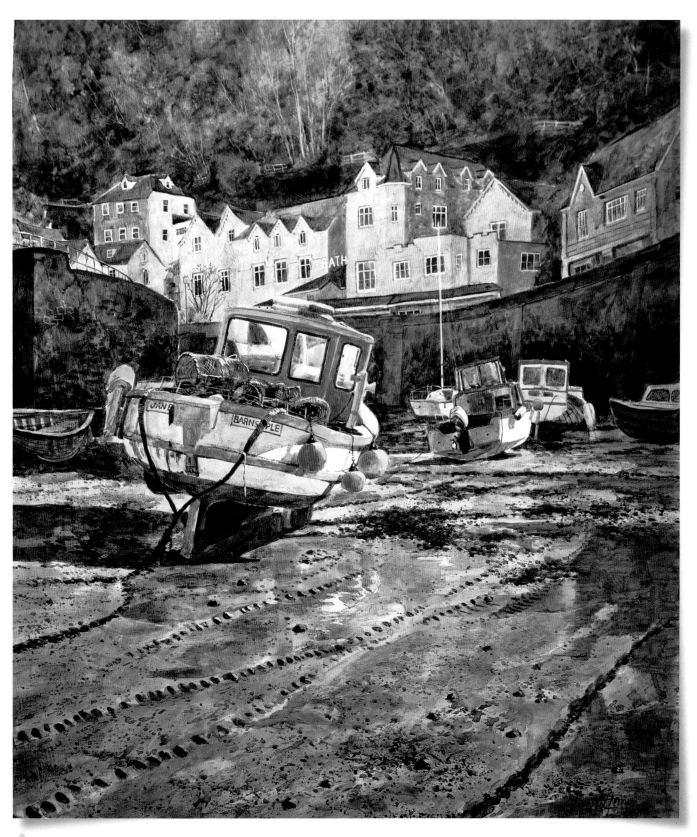

🖌 *Tide's Out*

60 x 70cm (23½ x 27½in)

When the tide is out, the boats always sit at these lovely jaunty angles. This boat in Lynmouth harbour
was a lovely subject to paint, with its bright blue and white paintwork and vivid pink fenders.

Paint colours: madder brown, cobalt blue, cobalt turquoise, transparent violet, Indian yellow, burnt sienna, French ultramarine
Brushes: size 4 flat, size 6 round
Other: clear painting medium, tracing number 14

Towering cliffs

We are now moving on to a more majestic landscape of towering coastal cliffs. I suggest you really let rip with your underlying textures on this subject and have some fun along the way. You will be able to pull the whole scene together with your unifying glazes and shadow areas.

1 Paint the sky with dilute cobalt blue and the size 4 flat brush. Once dry, mix madder brown with French ultramarine and paint the distant headland. Add a hint of transparent violet to texture it subtly.

2 Paint the sea with light touches of cobalt turquoise at the horizon, introducing cobalt blue in the midground, and transparent violet in the foreground. Swap to the rigger brush for the closest waves.

3 Spatter the cliffs with the size 6 round brush, using Indian yellow, madder brown and transparent violet.

4 Once dry, glaze the cliff face with a mix of Indian yellow, madder brown and burnt sienna. Use bold, scumbling marks using the whole surface of the brush, so that you can work quickly. Introduce hints of transparent violet.

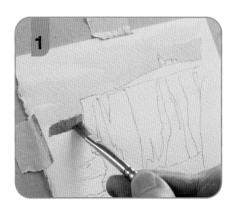

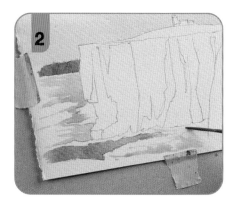

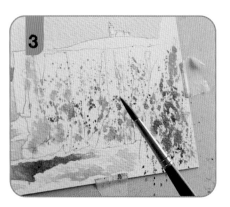

Technique: **Waves with the rigger**

There are no straight lines in nature, so this is a good way to create more natural-looking marks. Instead of pulling the tip of the rigger, push it gently. The bristles will waver slightly as they buckle, to create interesting wave shapes.

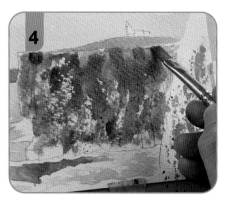

Acrylic medium

Mediums are materials that are added to paint to change its properties. There are hundreds of different mediums, including those that slow the drying time of paint, give it a matt finish or thicken the consistency.

This acrylic painting medium dries clear. Adding it to paint makes the mix really transparent. Less fluid than water, it helps the paint to flow without altering the surface tension, so it won't drip.

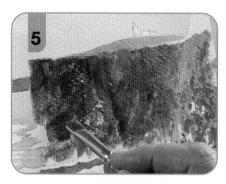

5 Mix clear painting medium with madder brown and transparent violet. Use this to add another glaze over the cliffs.

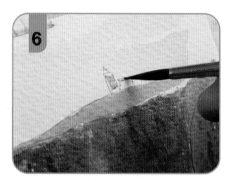

6 Use the tip of the size 6 round brush to add some of the same mix to the building.

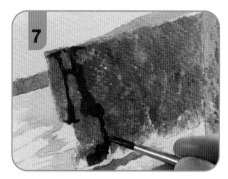

7 Make a dark, creamy mix of madder brown, burnt sienna, French ultramarine and transparent violet. Use this to 'punch up' the shadows with strong sharp shapes, then dilute the mix and lightly spatter the area.

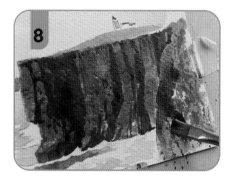

8 Build up the tone on the right-hand side to finish.

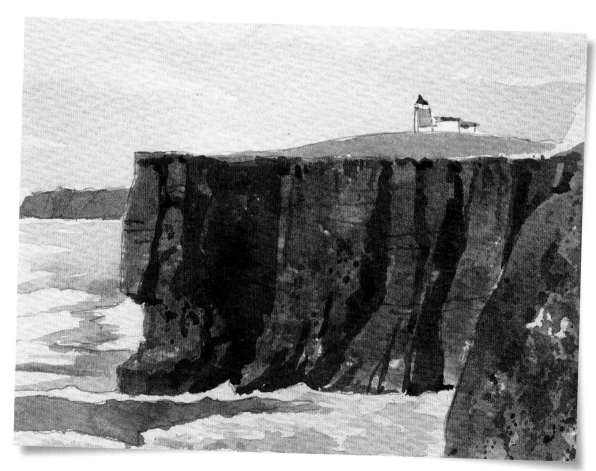

YOU WILL NEED

Paint colours: cobalt turquoise, titanium white

Brushes: size 4 rigger

Other: tracing number 15, masking fluid and old brush

White water

Acrylics allow you to paint over other colours both transparently – as with the glazes earlier – and opaquely, overpainting the colour underneath entirely. This makes it possible to add great variety in your highlights, with contrasting character in the whites between the clean paper and the white paint.

Another way to utilize white in your painting is by reserving the white of the paper using masking fluid, a rubber masking solution. Being rubber-based, it will resist water, and prevent wet paint getting to the paper – so you can paint over it. Once the paint is dry, you can rub it gently away, revealing the white of the paper.

Technique:
Applying masking fluid

Beware! Masking fluid is not a friend to your brushes. Please use old brushes, as masking fluid will dry in the hairs and ruin your good brushes. You can instead buy a reputable brush cleaner that will clean masking fluid from the bristles.

1 I'm using masking fluid here to create foam trails in the water, which I want to be as bright as possible. The whitest white I can get is the white of the paper, so we use masking fluid to reserve the space. Use your rigger brush to pick up the masking fluid from the pot.

2 The marks you make when applying masking fluid are the marks that will be revealed when you take it off, so apply them in a painterly manner, with thought towards how they will look in the final painting. Don't plaster it on, or you'll end up with large ugly white worms. Instead, make considered marks.

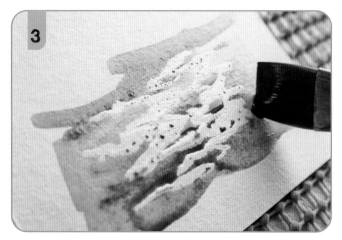

3 Allow the masking fluid to dry naturally – don't use a hairdryer to speed it up. Once completely dry, you can paint right over it.

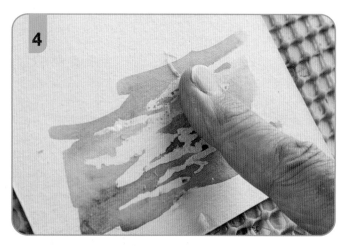

4 Once the paint has dried, use a clean finger to gently rub away the masking fluid, revealing the clean white paper.

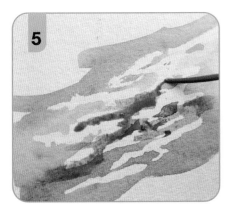

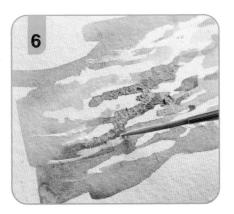

5 You can now develop the area further, if you wish, to accentuate areas.

6 Here I've used titanium white to add some extra tiny details over the blue – it's opaque enough to cover cleanly.

Technique:
Light over dark
Titanium white is a beautiful opaque white paint that can be used to add light over dark. It is fantastic for overpainting details – those little bits of jewellery that make a painting sing. Titanium white won't give you as white a result as the paper, but it's a close second.

To overpaint successfully in this way, the white paint must be used almost neat. You should wet the brush before loading it, but there's no need to pre-dilute the paint itself.

PUTTING IT INTO PRACTICE

I did this painting on canvas board. The masking fluid was applied to the breaking wave, the wave patterns and the water rivulets on the rock. The background sea was then painted with a predominately cobalt blue mix, adding yellow and cobalt turquoise as I moved into the foreground sea area. The rocks were a brown, orange and violet mix, the textured surface then spattered with darker paint. The final spray patterns were flicked on with creamy white paint.

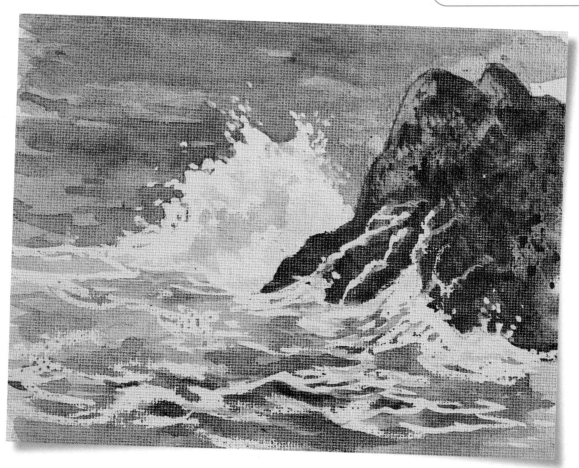

Beachscape

YOU WILL NEED

Paint colours: madder brown, Indian yellow, French ultramarine, transparent violet, cerulean blue, burnt sienna, titanium white

Brushes: size 4 flat, size 6 round, size 4 rigger

Other: tracing number 16

To make this subject work we have to portray both the wet and dry areas of sand. I have painted this example directly, leaving all the white areas unpainted. However, if you prefer, you can always mask out the main foam lines with masking fluid which could help with your flow of paint.

1 With the size 4 flat, paint the background cliffs and sky with a mix of madder brown, Indian yellow, French ultramarine and transparent violet, varying the mix with cerulean blue for interest. Use Indian yellow with a touch of madder brown to paint the dry sand on the right-hand side.

2 Add a hint of transparent violet to paint the wet sand where it meets the sea, applying the paint with a tapping motion of the corner of the brush.

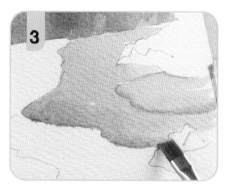

3 Paint the distant wet sand with dilute madder brown, then add a hint of transparent violet to the madder brown on your palette. Working wet in wet, add a subtle touch to darken the colour nearer you.

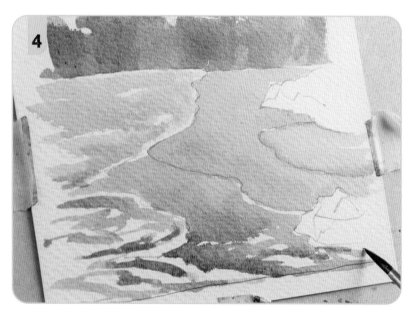

4 Using the wet sand mixes, paint the shallows of the sea. Leave a few gaps of white paper, but don't worry about leaving space for the foam. Since we're using acrylics, we can overpaint very easily later. With that said, nothing is as white as the white of the paper, so a few gaps here and there will help to add variety. In particular, leave gaps between the main areas, marked by the lines on the outline.

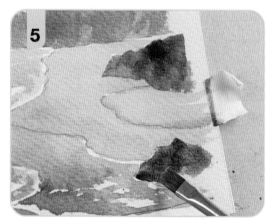

5 Using the size 4 flat brush with a creamy mix of burnt sienna and cerulean blue, paint in the rocks. Suggest the texture with short, choppy marks. Allow the painting to dry completely.

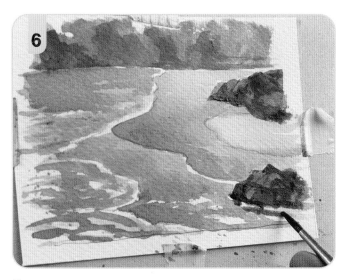

6 Build up the impact with glazes and the size 6 round. Strengthen the area of wet sand with the same colours, but use more Indian yellow than madder brown this time. Add a hint of transparent violet for the border of darker sand nearest the sea. The sky and distant sea can be glazed with the same mixes as before. On the rocks, bring out the texture and create shape by overlaying just parts of them. Dilute the rock mix to add the small area beneath the water's surface.

7 Use the size 4 rigger to pick up titanium white and carefully paint the ripples and foam.

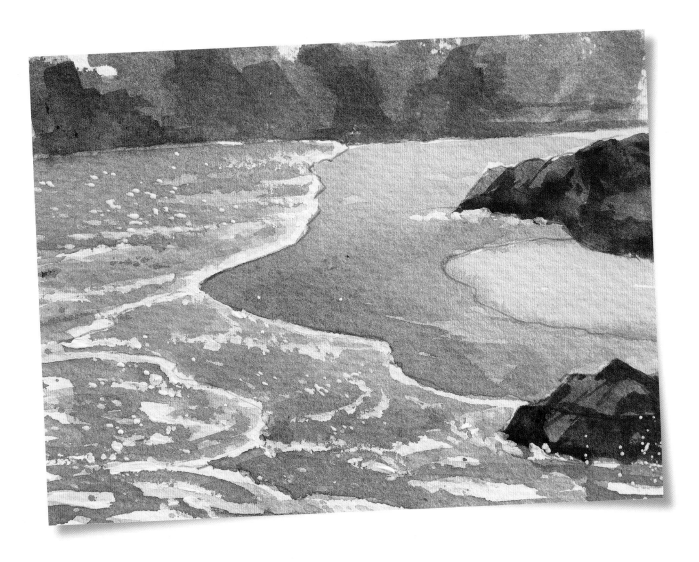

Rough seas

YOU WILL NEED

Paint colours: Mars violet, transparent violet, cobalt blue, cobalt turquoise, phthalo turquoise, titanium white

Brushes: size 4 flat, size 6 round

Other: tracing number 17

The surface of a canvas board primed with gesso is almost 'slick', and less absorbent than paper. As a result, wet paint can travel and flow further than on paper. We can use this to good effect, particularly for landscape subjects that involve water.

1 Use the size 4 flat to paint the sky with a mix of Mars violet, transparent violet and cobalt blue. Keep this fairly dark, as it will need to create contrast with the wave.

Technique:
Tipping and tilting

Left upright, the paint will slide down any areas of colour, and pool at the bottom. However, if we tilt the board while we work, we can encourage the paint to move in ways that enhance the shapes of the drawing, and create a sense of movement.

It is as simple as applying the paint, then picking up the board and gently tipping it in the direction you want the wet paint to flow. Once the paint has settled into your desired position, lay the painting flat to dry.

2 Apply very watery cobalt turquoise to the surface of the wave. Tip the board to encourage beads of paint to form, then shepherd them along the lines of the wave with the tip of the brush.

3 Once dry, make a sea blue mix from cobalt blue, transparent violet and phthalo turquoise, and paint the surface of the sea.

4 Tip the board and use the tip of the size 4 flat brush to paint the lines of the wave, gradually building up the marks to build the curve of the wave. Change to the rigger brush for finer details, if you find it helps. Leave the board flat to dry.

5 Using a slightly less watery sea blue mix, spatter it over the surface of the wave. Tilt the board up so that the marks follow the flow of the wave.

6 Add some cobalt turquoise touches with the tip of the size 6 round, joining some of the wet spatter marks.

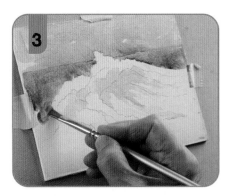

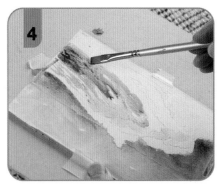

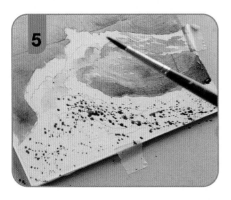

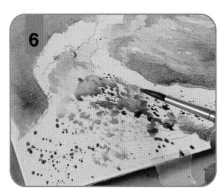

 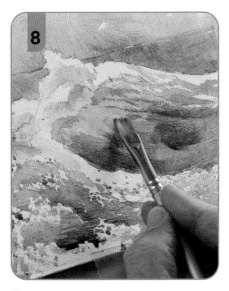 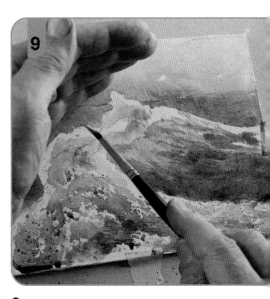

7 Spatter clean water into the same areas to join more areas of paint, then continue to build up the texture with more spattering, tilting the board to help get the lines of spatters running in the appropriate direction. Vary the colour of the sea blue by picking up different proportions of the same colours from the pool on your palette.

8 Using cobalt turquoise near the crest of the wave, and a mix of cobalt turquoise and the sea blue mix lower down, add some more marks to build up the strength of tone. This is essentially a glaze, but done with a slightly creamier mix than usual.

9 For a finishing touch, spatter on some dilute titanium white over the light areas of the wave, guarding the sky and background with your hand.

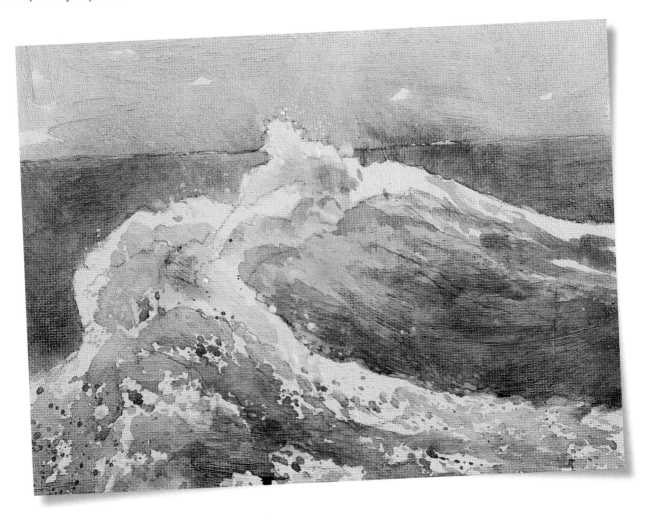

Evening on the estuary

YOU WILL NEED

Paint colours: lemon yellow, quinacridone red, transparent violet, Indian yellow, cobalt blue, madder brown, phthalo turquoise, cobalt turquoise, French ultramarine, burnt sienna

Brushes: size 4 flat, size 6 round, size 4 rigger

Other: tracing number 18

Boats at low tide settle at some jaunty angles, which often makes for interesting subjects. This exercise brings us into the realms of counterchange: light against dark, dark against light. Using this effect well gives a painting impact. You'll notice here how the highlighted tops of the boats shine out against the darker background, while the dark blue hulls contrast against the lighter estuary bed.

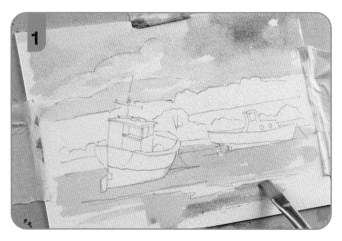

1 Use the size 4 flat to paint the sky very loosely using lemon yellow and quinacridone red, introducing transparent violet on the right. Paint the mud with a green-tinged brown mix of lemon yellow, Indian yellow and cobalt blue.

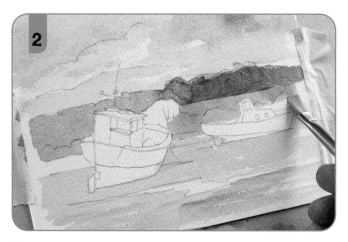

2 Use madder brown to paint in the tops of the distant trees, then make a grey with transparent violet and phthalo turquoise to paint in the lower parts all along the horizon. Make a green from cobalt turquoise and lemon yellow, then use it to paint in the remaining background.

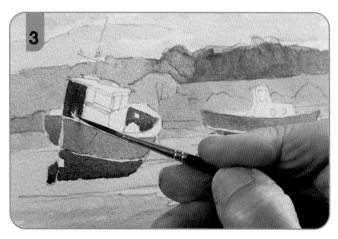

3 Switch to the size 6 round and begin to block in the boats with creamy colour – thicker paint is easier to control. Use cobalt blue for the upper hulls, then use a dark mix of French ultramarine and burnt sienna to paint the lower parts and inside. Add more burnt sienna to the mix and paint in the cabin, then allow to dry.

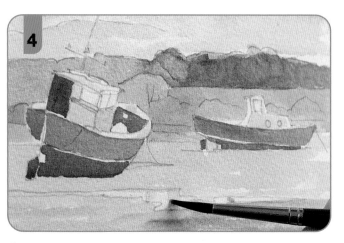

4 Add some subtle shadow on the boats and in the standing water with a mix of phthalo turquoise and a touch of transparent violet.

5 Mix Indian yellow, cobalt blue and transparent violet, and use the size 4 flat to overlay the mud with this green-tinged colour. While wet, spatter the same mix over the area with the size 6 round, tilting the board to help the spatters lie in the right direction.

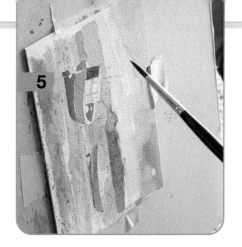

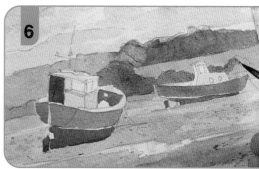

6 Strengthen the mix with more paint, and build up the dark tones in the trees behind the boats. Because the boats are light in tone, dark shapes behind them act as a foil, creating impact.

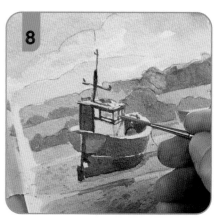

7 Use the same mix for the cast shadows beneath the boats, then use dilute French ultramarine to shade the blue areas of the boats.

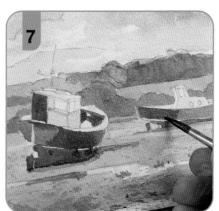

8 Switch to the size 4 rigger and use the creamy dark mix (see step 3) to detail the boats. Aim to make the marks nice and sharp, and don't over-do them. Wavering uncertain strokes will look awkward, so trust yourself: plan the stroke before you make it. You can add some spattering with the same mix as a finishing touch.

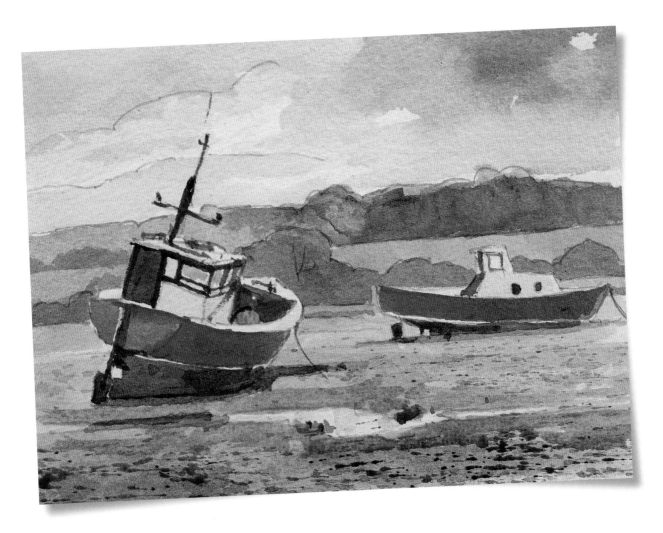

Harbourside

YOU WILL NEED

Paint colours: Indian yellow, madder brown, transparent violet, cobalt turquoise, transparent orange, burnt sienna, cobalt blue, phthalo turquoise, French ultramarine

Brushes: size 4 flat, size 6 round, size 6 rigger

Other: tracing number 19

A simple harbour scene that has houses, textured harbour walls, water, reflections – and boats! There is a bit of everything to get your teeth into.

1 Using the size 4 flat, establish the local colour first. We're just looking for very basic 'building blocks', so be general. I'm using a brown mix of Indian yellow, madder brown and transparent violet to lay in a variegated wash over the stone areas. I'm varying the proportions to ensure things don't all flow into one. Similarly, the shadows on the white buildings are all blocked in with a mix of cobalt turquoise and a little transparent orange. Paint the water with combinations of cobalt turquoise and burnt sienna, bringing in a little of the brown stone mix for reflections of the harbour walls at the waterside.

2 With the main blocks in place, the scene looks a lot less complex and intimidating, so we can enjoy the rest. Paint the central tree using a combination of phthalo turquoise and Indian yellow. Switch to the size 6 round brush and paint the left-hand tree with cobalt turquoise and Indian yellow. Use the brown stone mix for the boat with a cabin, and cobalt blue for the foreground boat. Add madder brown to the cobalt blue and begin to paint the rooftops. Introduce Indian yellow to vary the mix for some rooftops – I avoid everything being identical in colour; it looks boring. Using even slight variations helps to make the painting more inviting and arresting.

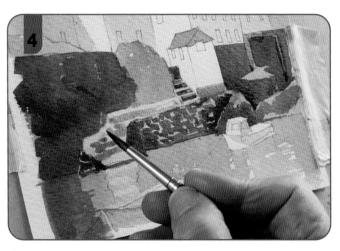

3 Return to the size 4 flat and build up the shadows on the stone with a mix of burnt sienna and French ultramarine, adding transparent orange for a hint more warmth.

4 Use the tip of the size 6 round to paint in smaller details like the shadows on the steps and the brickwork on the harbour.

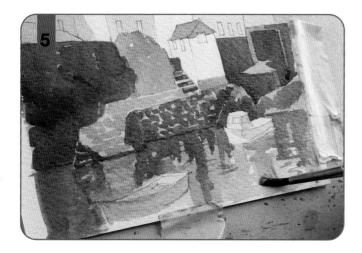

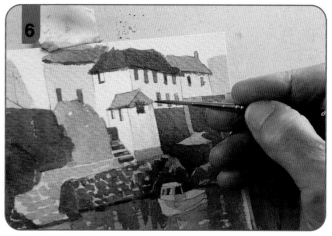

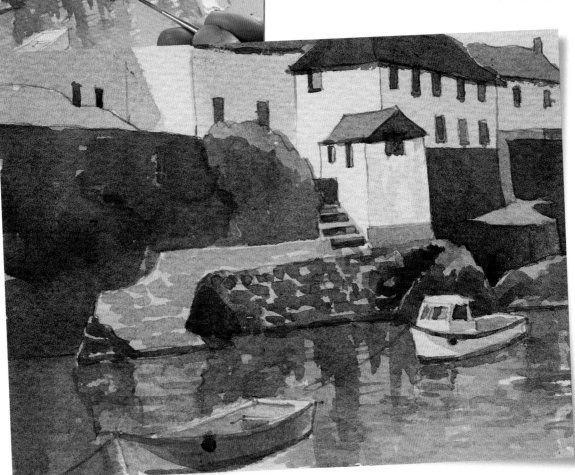

5 You can introduce variety through tone as well as hue – simply watering down the same mix will give you more options. Add reflections using broad downward strokes of the side of the brush, then use the tip to add some fine horizontal meandering marks.

6 Use a mix of French ultramarine and burnt sienna to paint in the windows with the size 6 rigger.

7 Use the rigger and pure colours (I've used transparent orange and titanium white) to add some further details on the boats, then pick out some finishing details with the mixes remaining on your palette.

TOWN AND COUNTRY

We now move on to buildings within the landscape, which covers everything from imposing country manor houses to characteristic cottages. Barns, in all shapes and forms, can really add to the sense of a rural idyll and are such fun to paint, especially if they are not too pristine and are in a rather dilapidated state. All the lovely textures you can create within the structure are limitless.

If you aren't that good at drawing, remember that you always have the tracings at the front of the book to help you out. This book is all about learning to paint with acrylics, so the drawing aspect is secondary in this case but that doesn't mean it isn't important – it is! It's just that I want you to concentrate on the painting and not get hung up with the drawing at this point in time.

Townscapes are also great fun to paint with all their myriad styles of buildings and alleyways. Also, shadows play a very important role in producing a truly three-dimensional rendering of the subject and I have concentrated on this aspect in our exercises.

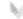
Bocairent, Valencia
60 x 70cm (23½ x 27½in)

We came to paint this small hilltop town of Bocairent in Spain on a blazingly hot day, so it was with some relief that we found an area opposite, in the shade of a huge wall. I did a double-page watercolour painting in my sketchbook on site. On my return to the accommodation, I did this large acrylic on canvas in the owner's studio using her brand of acrylics, which I had never heard of before. I think I managed to get something half decent down.

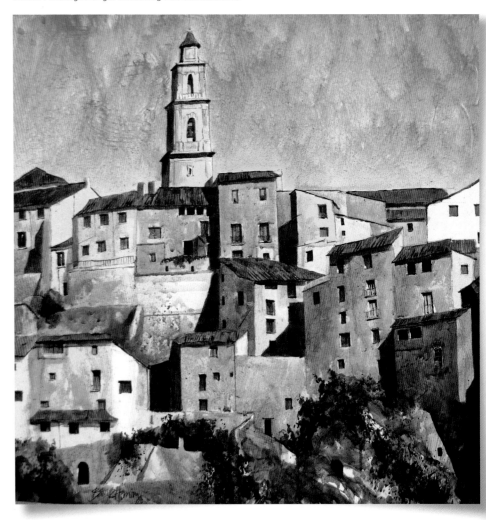

Field Boundaries

54 x 61cm (21¼ x 24in)

Driving around the Ring of Kerry in Ireland, you are presented with a patchwork quilt of interlocking fields, each with its own stone wall boundaries.

Country lane

Living as I do in the heart of rural Herefordshire, country lanes abound – and I just love painting them. Wherever you live, I'm sure you won't have to travel far before you come across your own paintable country lane, so keep your eyes peeled next time you're out and about.

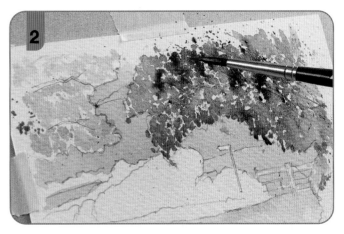

1 Paint the distant fields with a variegated wash of transparent violet, cobalt violet and lemon yellow. Vary the proportions across the painting, using more transparent violet in the distant background, and none closer up. Since this is distant, we want to keep the colours fairly muted – this will help the more vibrant foreground stand out. Use transparent violet and a hint of lemon yellow to block in the path.

2 Use the flick and tickle technique to paint the foliage of the foreground tree, starting with Indian yellow and successively building up with transparent orange, madder brown and transparent violet. Leave some gaps. Spatter some quinacridone red on the left-hand tree, then dilute French ultramarine and spatter it over the right-hand tree to mute the colour somewhat.

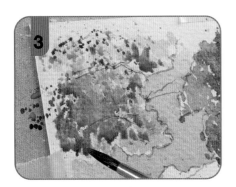

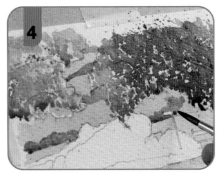

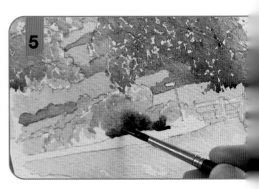

3 Use a mix of cobalt turquoise and lemon yellow to add some green to the left-hand tree, again using the flick and tickle technique.

4 With a very dilute grey-purple mix of transparent violet, French ultramarine and madder brown, add some background details.

5 Use Indian yellow to paint in the top of the foreground hedgerow, then introduce cobalt turquoise to build up the shape. Introduce French ultramarine at the base.

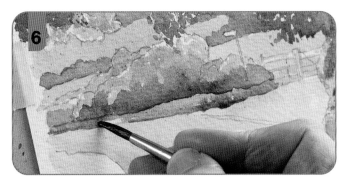

6 For the grass verge, introduce some darks with a mix of the same three colours.

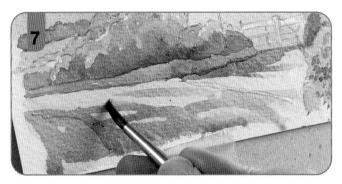

7 Add shadows across the road with controlled glazes of transparent violet and cerulean blue mix. Soften the edges with a damp brush.

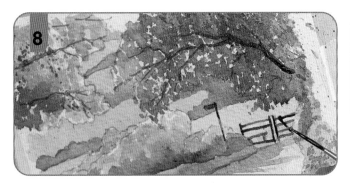

8 Combine transparent violet, French ultramarine and madder brown and use this dark mix to paint the branches, gate, stile and other foreground details with the rigger.

Technique: **Softening**

While paint remains wet, you can prevent a hard edge forming by drawing a damp brush over it – this will lift a little, but not all, of the colour, and leave a smooth, soft transition.

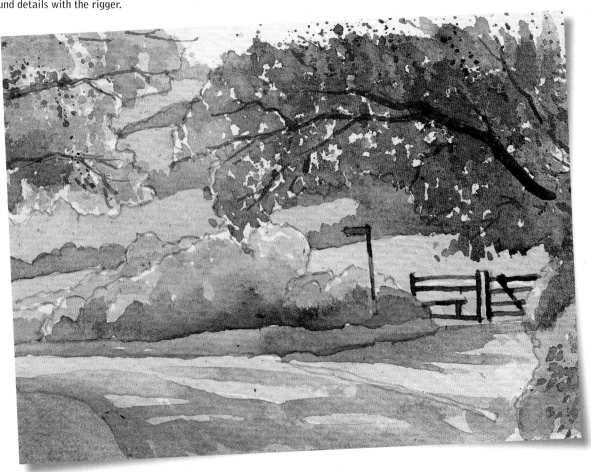

Rustic barn

Old barns really do present some super painting subjects, especially those that are a little worse for wear. This lovely group of barns nestle in the tiny hamlet of Malmsmead, in the heart of the Exmoor National Park in the UK. I have visited this place many times and have painted these barns from all angles. All the textures of their rusty roofs are a joy to paint.

1 Paint the sky with dilute cobalt turquoise using the size 4 flat, then use a green mix of cobalt turquoise and Indian yellow to paint in the green fields behind the buildings. Use the shape of your brush to your advantage – using the sharp corner to help you create clean lines.

2 Add transparent orange and madder brown wet in wet to add the area of bare earth on the right, then build up the foreground grass with the same colours as before, adding interest by adding pure Indian yellow wet in wet.

3 Switch to the size 2 flat. Use a mix of Indian yellow and madder brown to suggest texture on the building, twisting and turning the brush to cover the area lightly, leaving white spaces. Spatter the mix over the area with the size 6 round.

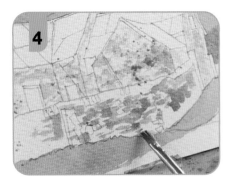

4 The tip of the size 2 is perfect for suggesting the stonework of the wall. Hold it so that the edge is horizontal, then tap it onto the surface to print a shape. Repeat the process to build up the suggestion. Turn the brush so that the edge is vertical when you come to the upright capstones on top.

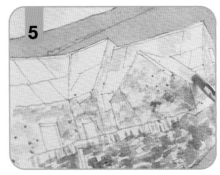

5 Use very dilute cobalt turquoise to paint areas of the roofs, then add transparent violet and Indian yellow to make a grey mix for the road. Combine the grey mix with the stone mix (see step 3) and use this new dark tone to reinforce the stonework a little. Allow to dry.

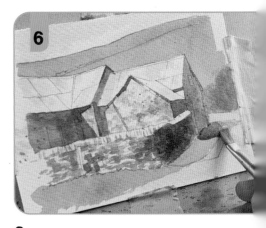

6 Switch to the size 4 flat, and create a mix of French ultramarine, burnt sienna, transparent violet and hints of quinacridone red and transparent violet. Use this to glaze the shaded areas of the building, again using the shape of the brush to create strong lines. Deepen the tone slightly with more French ultramarine and burnt sienna to paint the cast shadows – both those thrown on the buildings themselves, and on the grass and road on the right.

7 Change to the size 6 round brush and use the same mix to pick out the doorways and windows by overlaying them. Use the size 4 rigger to outline a few stones on the wall and pick out some other details like the drainpipe with the same mix.

8 Add a hint of transparent violet to transparent orange, and use the whole length of the rigger bristles to tap the roof; depositing the paint like a stamp. Check the angles of the brush matches the pitch of the roof.

9 Use the tip of the brush to tidy up the marks a little, then add more transparent violet to darken the mix. Add a few select details into the rusty roof. Less is more – don't overdo it.

10 Add a few dark green details to the background and foreground grass with a cobalt turquoise, Indian yellow and phthalo turquoise mix. Use any of the grey mixes on the palette to place some finishing touches, such as shadow around the post on the left, or some light drybrushing on the road.

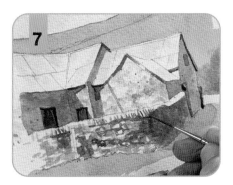

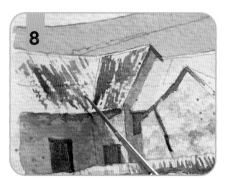

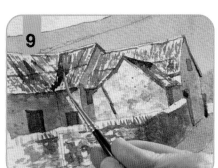

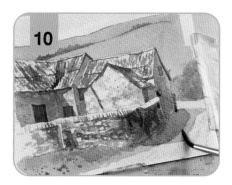

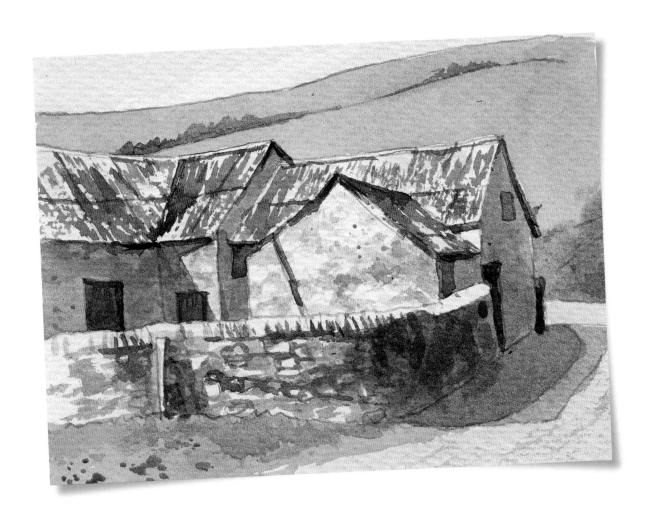

Paint colours: Indian yellow, transparent orange, madder brown, transparent violet, cobalt blue

Brushes: 16mm (¾in) flat, size 6 round

Other: tracing number 22

Successful shadows

Shadows are such an important and integral part of any landscape painting, but so often they are treated with a certain lack of emotion; as though the artist is just going through the motions.

I love shadows and when painting outdoors I take time time to evaluate the different hues and strengths of all the shadows and the areas affected by them. Once you start to look into your shadows you will see what I mean about their importance, and your paintings will take on a new lease of life.

This is a Mediterranean scene, with all that lovely characteristic warm light you associate with this beautiful part of the world. To properly capture that impression, I want shadows that impart a lovely glow of warmth. The two examples shown here were painted with exactly the same basic wall, lane and tree colours – but just look at the difference the shadows make!

DISAPPOINTING DULLNESS

To illustrate emotionless, dull shadows, I have mixed up a muddy, overmixed grey shadow colour (see below) and painted all the shadows and shadow areas with it in the painting here. Notice how cold and rather flat it makes the overall painting. The result of monotone grey shadows is more akin to a dull day in the UK rather than a sunny one in the Mediterranean!

Overmixed shadow pool

The pool here is made up from madder brown, cobalt blue, Indian yellow, transparent orange and transparent violet, all scrubbed into a muddy, boring monotone. The results will be flat and boring.

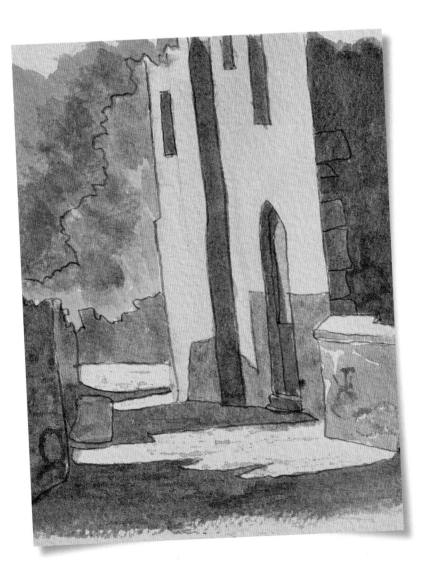

PUTTING IT INTO PRACTICE

Try it out for yourself. As with the example opposite, I painted the walls with a dilute mix of Indian yellow, a very dilute blue/brown mix for the lane and a blue/yellow mix for the trees. Keep these colours simple, as it is the shadows you want to concentrate on. Then mix up your shadow pool (see right) and start to paint in your shadows with more care, studying the painting below carefully to identify and apply the different hues.

By taking the different shades from my shadow pool colour on the palette and painting the various shadows with a corresponding colour, the painting comes alive and is imbued with a warm glow.

Good shadow pool

Areas of the different colours can be picked out, with lovely mid-range shadows in between. The pool here is made up from exactly the same colours – madder brown, cobalt blue, Indian yellow, transparent orange and transparent violet – but they are left to merge and mingle naturally, rather than scrubbed into a monotone. The colours all combine in the pool to make lovely vibrant neutrals, but if I want to apply a particular hue – perhaps to achieve a purple tinge to an area of shadow on my painting, for example – I can scoop up the paint from an area that has a greater proportion of purple.

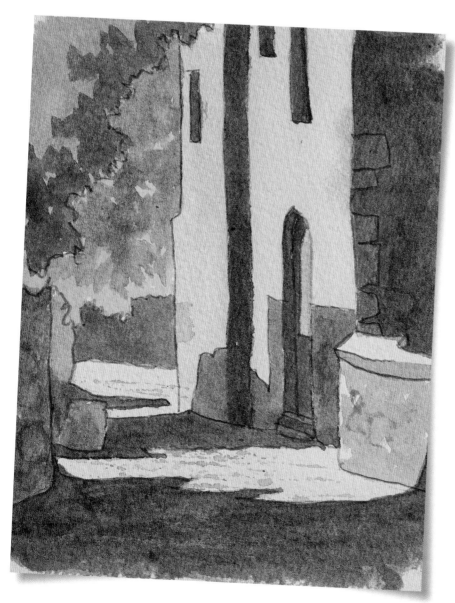

YOU WILL NEED

Paint colours: cobalt turquoise, cobalt blue, transparent orange, Indian yellow, lemon yellow, transparent violet, madder brown, French ultramarine, burnt sienna, phthalo turquoise

Brushes: size 6 round, size 4 rigger

Other: tracing number 23

Townscape

Townscapes can fill the novice with a certain apprehension. When faced with an array of unusually-shaped buildings at irregular angles, as here, the secret is to simplify!

A street scene in full sunlight does not have the drama of that same scene infused with some lovely unifying shadows. You will become aware of just how important these shadows are as you work through this exercise.

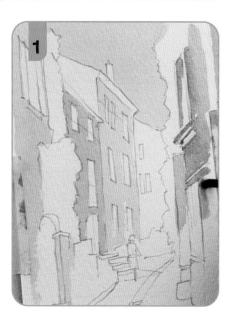

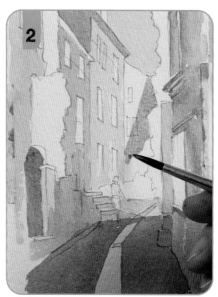

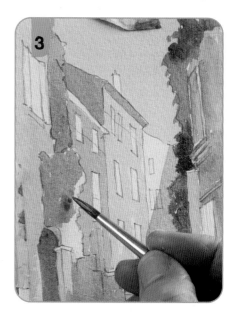

1 Using the size 6 round, paint a simple sky using cobalt turquoise with a hint of cobalt blue. Paint in the buildings with combinations of transparent orange, Indian yellow, and lemon yellow. Add touches of transparent violet and/or madder brown to the selection for the areas in shadow.

2 Use the same sky mix for the centre of the road; then use a dilute mix of French ultramarine, transparent orange and burnt sienna for the road, doorway on the left and cast shadow on the white building.

3 Use a combination of cobalt turquoise and Indian yellow to paint in the tree on the shaded side, adding transparent violet to vary the hue. Paint the tree on the sunny side in the same way, substituting the Indian yellow with lemon yellow.

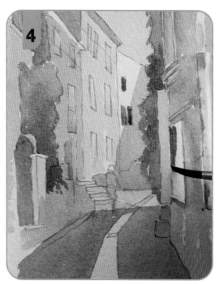

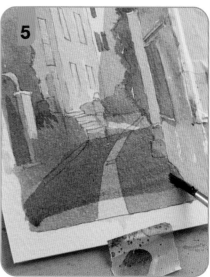

4 Use a variety of different blues for the different houses' windows: I've used dilute cobalt blue for the windows in the pink-orange house, and dilute cobalt turquoise for the windows in the yellow house, for example.

5 Combine transparent violet with a hint of transparent orange and use this to paint a flat wash for the main shadows across the road – note in particular how the blue central area becomes much less strident with the glaze over the top.

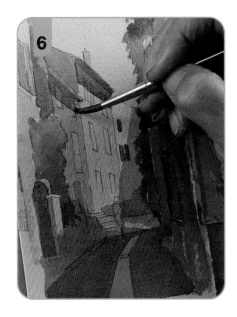

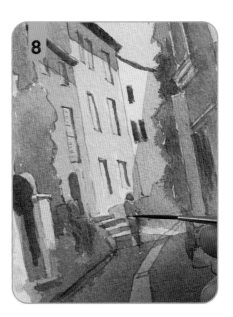

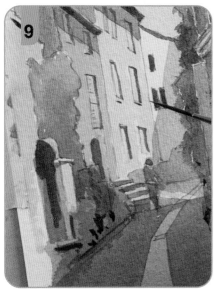

6 Knock back the wall on the right in the same way, along with the shadows under the eaves on the left-hand side of the street.

7 Use Indian yellow to paint in the figure's coat, then use the shadow mix to paint her head and legs.

8 Strengthen and adjust the finer shadows across the painting.

9 Use the size 4 rigger to develop the detail in the windows, chimneys and similar small areas. This adds definition and interest for the eye to rest upon.

Paint colours: Indian yellow, transparent violet, lemon yellow, cobalt blue, French ultramarine, burnt sienna, madder brown, titanium white, cobalt turquoise

Brushes: size 4 flat, size 6 round, size 6 rigger, size 4 rigger

Other: tracing number 24

Country cottage

Buildings in the landscape come in many shapes and sizes: from modest country cottages, to comprehensive collections of farm buildings. For this exercise I have chosen a lovely stone cottage on the island of Orkney, with a farm track that leads us into the picture.

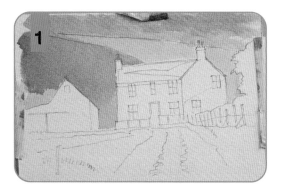

1 Use Indian yellow to paint the moors with the size 4 flat, then add transparent violet to the mix and paint that in wet in wet to bring out the darker areas.

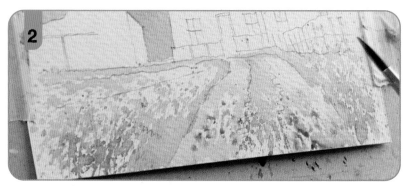

2 Use the size 6 round to flick and tickle a mix of lemon yellow, Indian yellow and a touch of transparent violet over the foreground. Use the back of the brush to join a few spots together and create the suggestion of grasses. Fill in the central area of the road in the same way. Repeat the process with phthalo turquoise, laying in some French ultramarine with spattering.

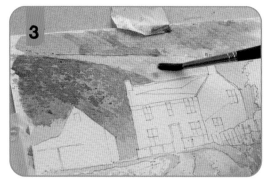

3 Add spattered texture to the midground moorland with burnt sienna, then use the side of the brush to add softer texture to the distant hillside.

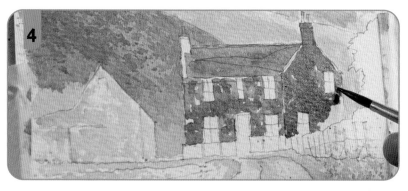

4 Add some broken texture to the outbuilding with a mix of cobalt blue and French ultramarine. Add burnt sienna to create a dark and use this to paint the roof of the cottage. Use the point of the brush to tap in some stone texture using a mix of madder brown and cobalt blue on the front of the house; then switch to a mix of transparent violet and burnt sienna to paint the gable end.

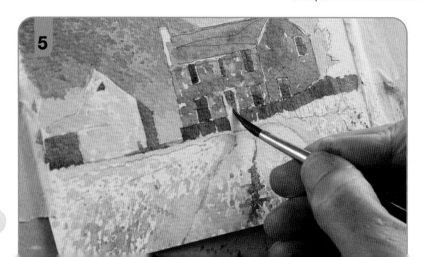

5 Paint the wall at the front of the house with a mix of cobalt blue, French ultramarine and madder brown; then use the same mix to detail the foreground. Darken the mix and paint in the windows. Use the same mix for shadows on the outbuilding, then add cobalt turquoise to the door.

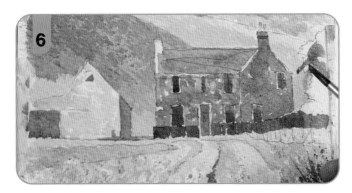

6 Use a combination of cobalt turquoise and lemon yellow to paint the grass on the left, then add hints of French ultramarine and burnt sienna to mute the green. Use this to paint in the tree.

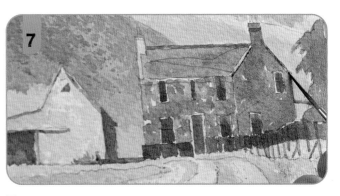

7 Use the size 6 rigger to apply a very dilute mix of the dark mix (French ultramarine and burnt sienna) to the fenceposts, chimney pots and other details.

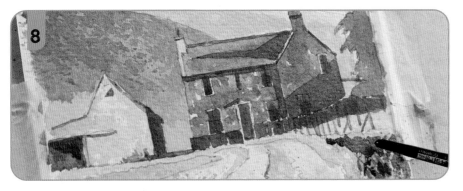

8 Add madder brown to the dark mix and paint in the shadows. Use more of the blue-tinged area of the mix to paint the cast shadow on the roof and on the road; and the warmer, browner part of the mix for the shadows on the stonework.

9 Add some finishing touches using the colours on your palette, then use titanium white and the size 4 rigger to pick out the window frames and sunlight on the fence.

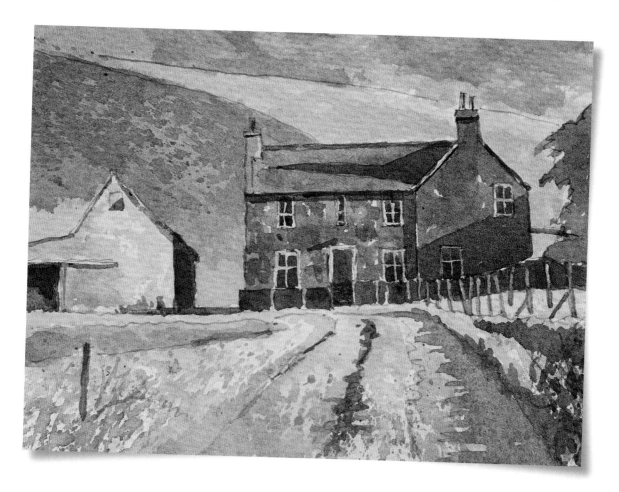

Paint colours: transparent orange, phthalo turquoise, transparent violet, Indian yellow, French ultramarine, cobalt turquoise, titanium white, lemon yellow, burnt sienna

Brushes: size 6 round, size 4 flat, size 4 rigger

Other: tracing number 25

Doorway

Sometimes, when exploring the countryside, you come across an exciting detail that takes your eye. This could be in the form of an old gate, an ornate window or, as in this case, a colourful rustic doorway. You don't always have to be looking for the big view: these vignettes can be equally satisfying.

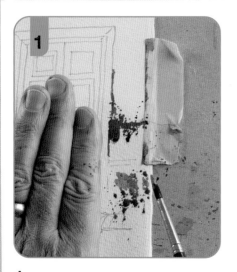

1 Using your hand to shield the doorway itself, flick paint onto the surroundings. This is a real chance to have fun – and the colours you use aren't particularly important. I've used transparent orange with a hint of transparent violet for some spatters that suggest exposed brickwork; a grey mix of transparent violet and lemon yellow for some dirt; and French ultramarine for some shadow at the top left.

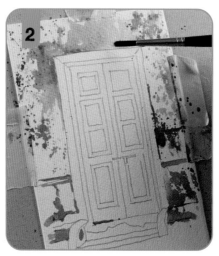

2 Build up the plaster all around the door in the same way, then pick out a few details with a shadow mix using combinations of French ultramarine, burnt sienna and transparent violet.

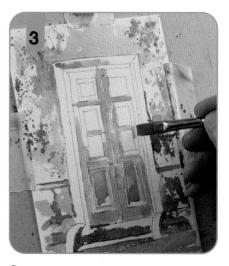

3 Combine cobalt turquoise and phthalo turquoise, and use the mix with the size 4 flat to paint the door. Don't treat this like decorating; you want to create a broken, textural effect. Add little areas and blocks with various parts of the brush, and vary the proportions of the colours. In this way, you will gradually build up variation in shape and tone.

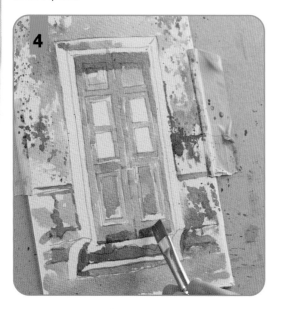

4 Darken the mix at the top and bottom with transparent violet; then work in some other shaded areas.

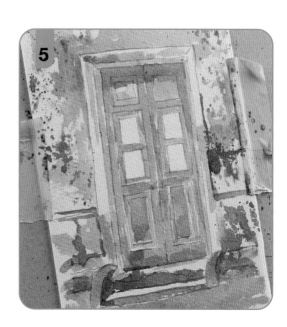

5 Use hints of transparent orange, Indian yellow and transparent violet to hint at colour on the door frame.

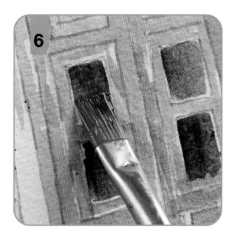

6 Pick up French ultramarine and burnt sienna on the flat brush, then use single vertical strokes of the brush to paint in each window.

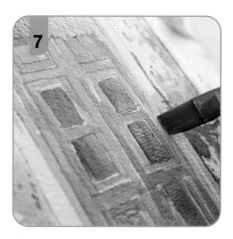

7 Add a little more transparent violet to the turquoise mix and build up the darks across the door.

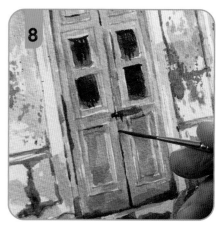

8 Use the size 4 rigger to pick out a few final details using a dark mix of burnt sienna and French ultramarine. Use the same brush and mix to add some dark around the doorframe.

Technique: Single stroke painting

As you can see above, elements of each colour remain visible when applied in one clean stroke. When you load the brush, try to pick up different colours on different parts of the brush.

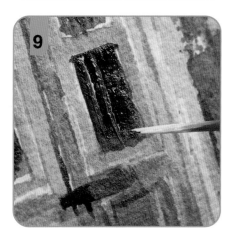

9 Use the rigger to add some titanium white detail on the windows.

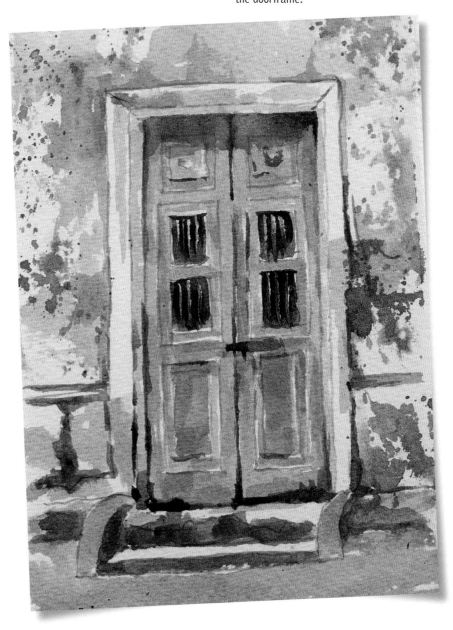

Ox-eye daisies

YOU WILL NEED

Paint colours: phthalo turquoise, cobalt turquoise, madder brown, transparent violet, lemon yellow, Indian yellow, cobalt blue, titanium white, French ultramarine

Brushes: size 6 round, 16mm (¾in) flat, size 6 rigger

Other: tracing number 26

I am not a flower painter *per se* but often include flowers in my landscape work. Wild flowers pop up everywhere in the countryside, in fields, woods and country gardens, so I have chosen a group of ox-eye daisies in a field. They also give you the chance to paint using thick, creamy paint to portray the petals, an approach that works well with acrylics.

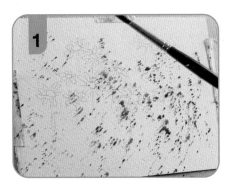

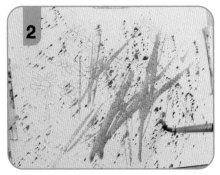

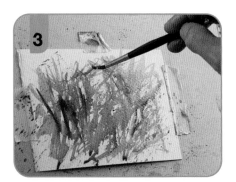

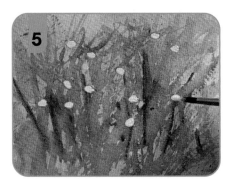

1 Make a large pool on your palette; bringing in areas of all the colours – don't over-mix them; let them blend on your palette. Pick up paint from a green-blue area and spatter it heavily over the surface with the size 6 round brush.

2 Make light flicking marks by holding the brush near the end and suggesting stems.

3 Repeat with a yellow-green mix, then again with brown-tinged stage. This creates a chaotic, textural underpainting.

4 Once dry, use the 16mm (¾in) flat brush to lay a blue-green glaze (picked up from the same pool as earlier) over the whole painting.

5 Use the size 6 round brush to paint in the centres of the daisies with titanium white.

6 Overlay the titanium white with Indian yellow.

7 Add a tiny hint of cobalt blue to the titanium white on your palette, and use this to place the shadowy petals.

Finding your way

If the underpainting has covered your pencil marks entirely, you can refer to the outline to help you find the daisy centres. Alternatively, you can simply retrace them over the top of the paint – just make sure that it's dry before you try it!

8 Use pure titanium white to build up the petals in the light.

9 Change to the size 6 rigger and paint the stems using a mix of French ultramarine and phthalo turquoise.

10 Shade the centres by painting crescent shapes on their lower right-hand sides with burnt sienna.

11 Build up the texture and brightness on some of the petals with another layer of titanium white.

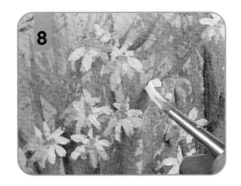

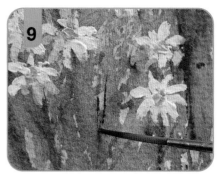

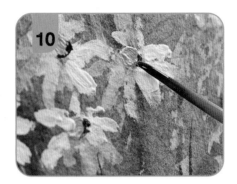

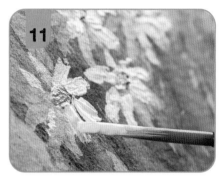

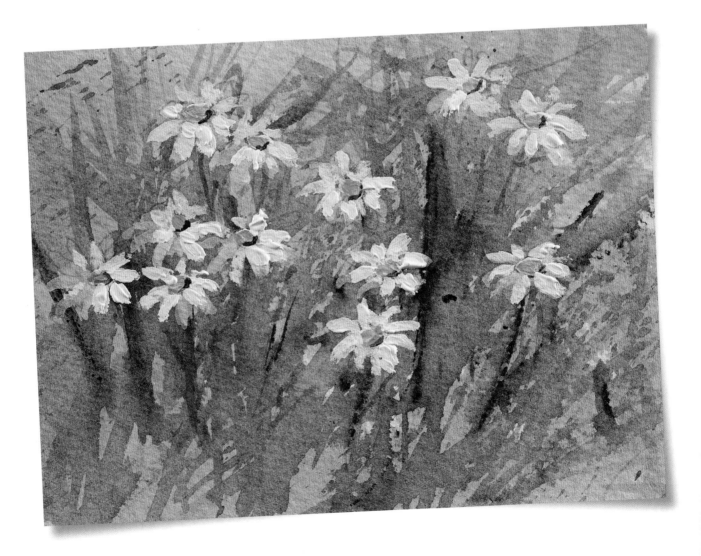

HILLS, MOUNTAINS AND SNOW

Highlands are very emotive; they are subjects that can produce paintings of high excitement. There are so many moods surrounding hills and mountains that it would be impossible to include them all in this section – but I hope the ones I have chosen will fire you up to experiment and produce some of your own.

I live in the Wye Valley in the UK, an Area of Outstanding Natural Beauty, where hills abound. The rolling hills of Herefordshire are a joy to behold and I have painted them in all their different moods. This leads me neatly onto another subject here: snow scenes.

In the UK, we don't get an awful lot of snow falling on our landscape, but when it does, it transforms a familiar scene into an altogether different vista. Once again, shadows play a very important part in giving shape to an otherwise flat, white scene.

Finally, we move on to the big guns – mountains! Having cruised up along the west coast of Norway, I've witnessed some really breathtaking and majestic mountains and really love getting to grips with these natural wonders. Please have a go and see what I mean (there's some snow here as well)!

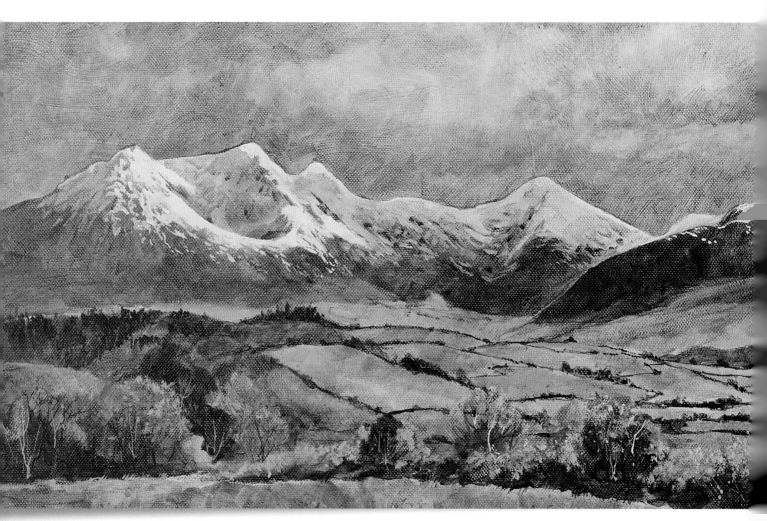

 ### Mountain Reflections

60 x 50cm (23½ x 19¾in)

On a cruise up along the Norwegian coast I encountered scenes like this at every turn. The fact that the snow had gone from the lower green slopes made for a more colourful scene and the glacier in the background counterchanged nicely with the dark green slopes in front.

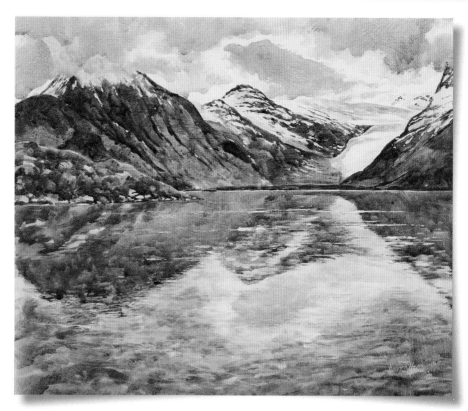

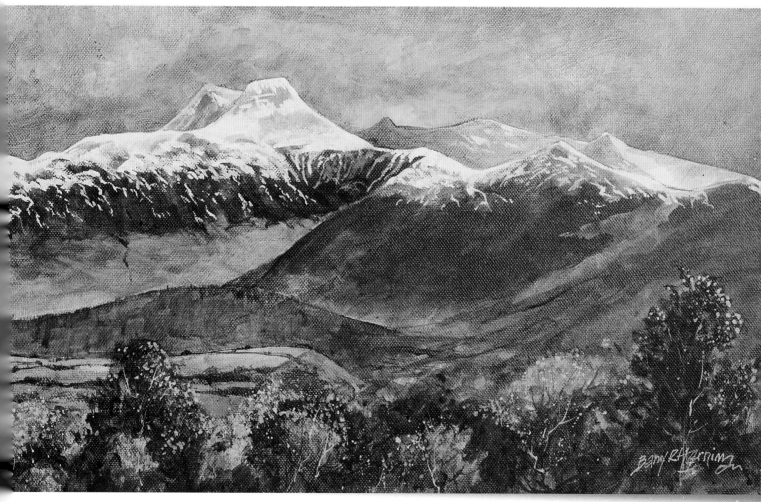 ### Snow on the Reeks

100 x 30cm (39¼ x 11½in)

Looking across the Atlantic Ocean towards the Iveragh peninsula from Dingle, Ireland, this was the first time that I saw snow on the mountains of MacGillycuddy's Reeks in County Kerry. To make it even more impressive was the fact that storm clouds were looming over them and the whole scene was lit up by a sunburst, making the whole area sparkle. A truly magical moment and one I wanted to capture on this panoramic canvas.

Hills

YOU WILL NEED

Paint colours: cerulean blue, cobalt turquoise, Indian yellow, transparent violet, phthalo turquoise, burnt sienna, madder brown

Brushes: size 4 flat

Other: tracing number 27

The rolling hills of Herefordshire, where I live, may not be as dramatic as the Scottish Highlands, but the interlocking fields can be just as satisfying to paint when they are bathed in sunlight and shadow.

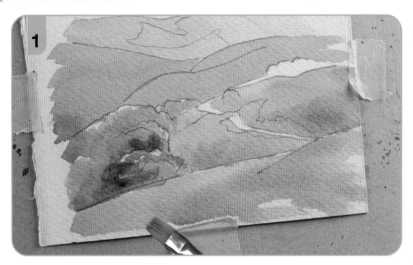

1 Use the size 4 flat to paint the sky with cerulean blue. Once dry, paint the distant hills with a mix of cerulean blue, cobalt turquoise and a hint of Indian yellow. Working forwards, paint the other hills in the same way, using increasingly more Indian yellow as you advance, and varying the mix to create interesting variety across the fields as a whole. In the foreground, introduce transparent violet and phthalo turquoise.

Glazing for drama

We have painted the image as though it is all evenly lit. Selectively adding shadows will now allow us to create mood and atmosphere. The trick is in making sure the shadows all look right, and face away from the light source.

Here, the sun is off to the right-hand side, so we need to make sure the areas that point away from it are darker than those that point towards it. This will obviously vary from hill to hill, but as long as we consider where the sun is, and make sure the light areas point towards it, we know to place our shadow glazes only away from these – generally, but not always, on the left-hand sides of each hill.

There is no such thing as shadow colour; shadow areas must be built up with glazes of the original colour, or a muted version of the same.

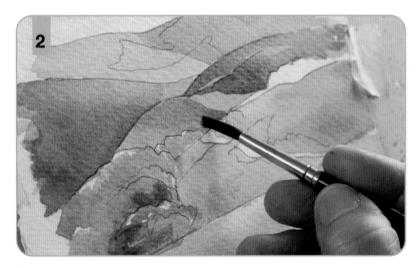

2 Begin to build up the shadows, starting with the distant hills. Cover the right-hand hill with a glaze of the same colours as before (cerulean blue, cobalt turquoise and a hint of Indian yellow). Use a mix of Indian yellow, burnt sienna and transparent violet to glaze the hill on the left-hand side. Continue to build up the shadows across the remaining hills with the same mix. To get the impression of roundness, we need to avoid hard edges; so, where necessary, soften the wet shadow colour to blend it into the hill smoothly.

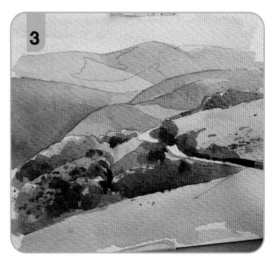

3 Build up some details in the foreground with the same mix, introducing madder brown.

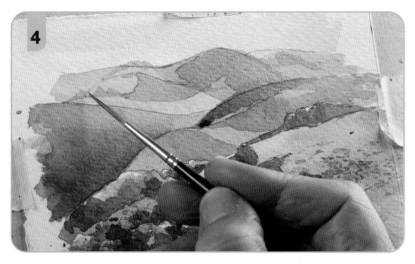

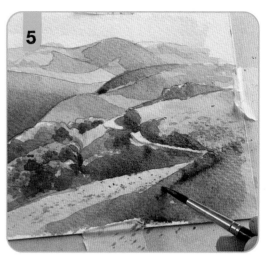

4 Paint the foreground hill in shade with the green-tinged mix (cerulean blue, cobalt turquoise and a hint of Indian yellow), then use the same mix to add a few stands of trees in the distance. The shadows you have already put in will ensure that the correct areas of the trees already appear shaded.

5 Add some spattering to finish.

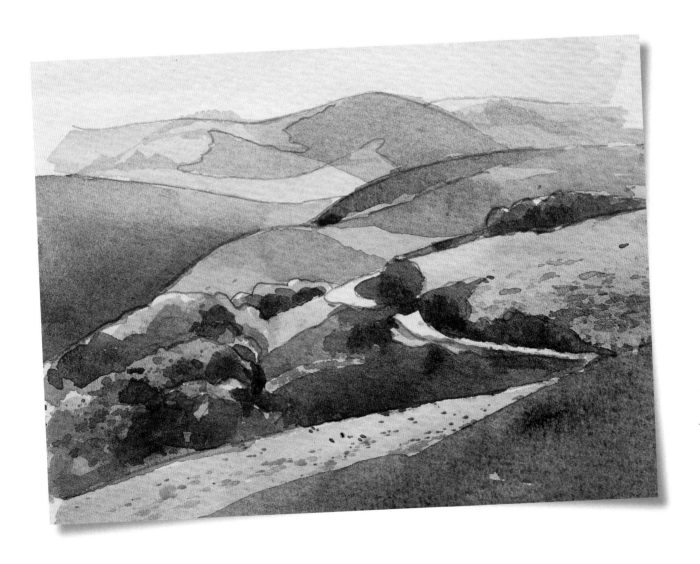

Misty mountains

The gradual build-up of tone is essential to the success of the mist effect. You need strong dark tones to achieve the correct contrast. Tinting white is a great way to overpaint a darker area without the passage becoming too opaque.

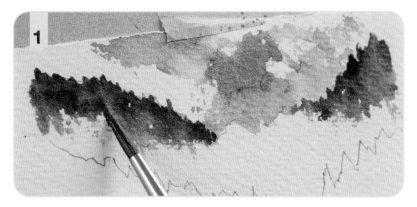

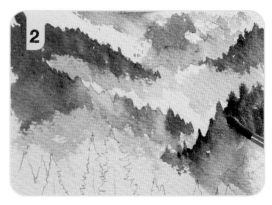

1 Use combinations of burnt sienna, transparent violet, Indian yellow and a touch of French ultramarine to paint in the sky. Strengthen the mix with more French ultramarine and paint the distant fir forest. Vary the mix with cerulean blue in the midground. Paint the tops of the trees, but soften the lower edges with clean water, so the tree line blends away into white.

2 Use a dilute wash to overlay the lower parts of the forest in the midground, then strengthen the tops of the trees with the original mixes.

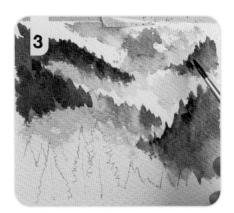

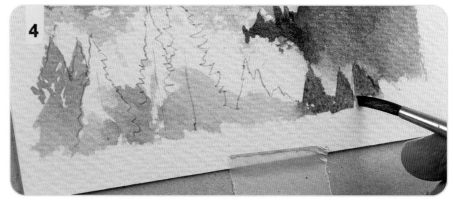

3 Use a dark mix of French ultramarine and burnt sienna to build up the strength at the tops once more.

4 Paint the foreground with a more dilute version of the same mix, introducing phthalo turquoise.

5 Strengthen the mix once more, adding more transparent violet and phthalo turquoise, and use the size 4 rigger to develop the foreground trees.

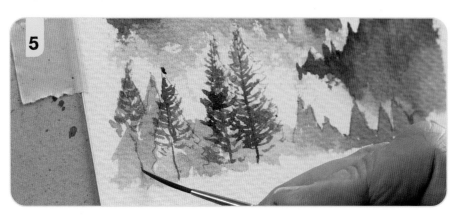

Technique: **Impasto**

Using tinting white to knock back strong darks relies on you working relatively thickly, a technique called impasto. You don't need to dilute the paint at all – just apply it straight on with the brush.

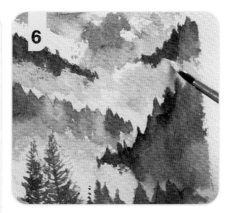

6 Add a hint of cerulean blue to the tinting white (pearl titanium) on your palette, then use the size 6 round to apply it over the lower parts of the dark area, blending it into the gaps and light tones below.

7 Vary the effect by adding in titanium white here and there.

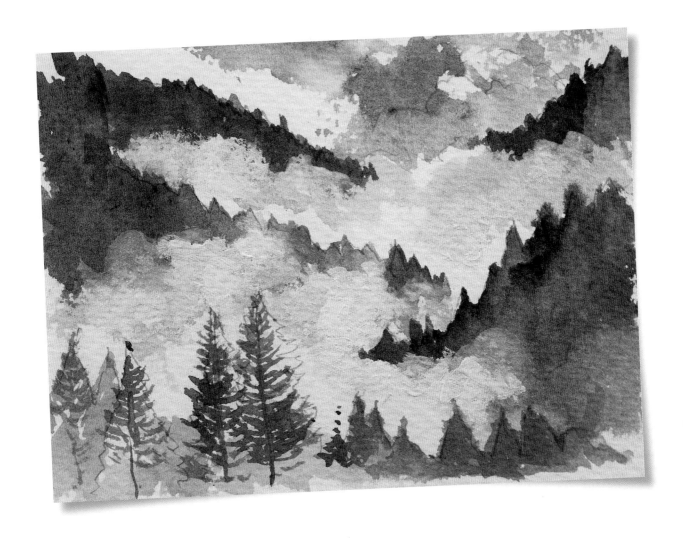

YOU WILL NEED

Paint colours: cobalt turquoise, cobalt blue, transparent violet, burnt sienna, Indian yellow, madder brown, transparent violet

Brushes: size 4 flat, size 6 round, size 6 rigger, size 4 rigger

Other: tracing number 29

Snowy lane

Snow scenes look best when – perhaps surprisingly – there isn't much white. You should save the white of the paper for those parts where you want a real sparkle. For the rest, subtle blues help create shape, interest and contrast.

1 Use the size 4 flat to paint the sky using a fairly dilute mix of cobalt turquoise with a hint of cobalt blue. Work carefully around the buildings and – ideally – the trunks of the trees. Don't worry about the finer branches – paint straight over these.

2 Starting with the rearmost fields on the left, add the shadows on the snow using a mix of cobalt blue, cobalt turquoise and transparent violet, and keep it fairly dilute. We want these distant shadows to be very pale, so that the foreground shading doesn't need to be too strident to read out.

3 Build up the shadows across the rest of the snow, using the edge of the brush to help create crisp edges where necessary. Add a hint more cobalt blue in the foreground, but keep the paint overall light in tone – snow scenes are full of reflected light.

4 Switch to the size 6 round and add some burnt sienna touches to the walls, and develop them with more blue added wet in wet. Leave plenty of space between these marks.

5 Mix burnt sienna, Indian yellow and madder brown and paint in the houses themselves. Vary the mix with a little transparent violet for the garden walls. The critical part is to keep the top of the walls as crisp, clean paper, to create the illusion of bright snow.

6 Once dry, add the trees with a mix of madder brown, burnt sienna, Indian yellow and a touch of transparent violet. Add French ultramarine for the darker areas, and use the size 6 rigger for the branches.

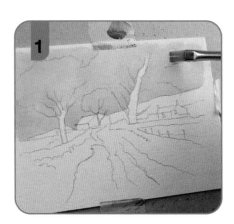

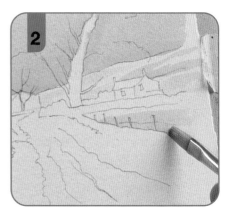

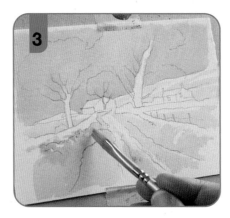

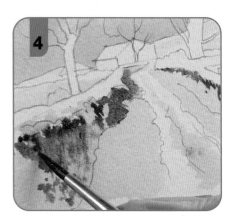

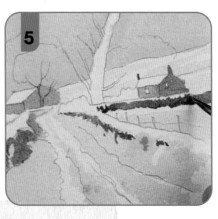

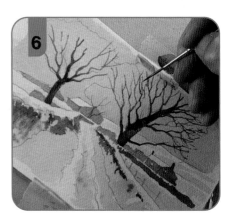

Twists and turns

Turn the painting upside-down for the finer branches, if it helps. Secondly, remember to pull, not push, the rigger for smooth strokes.

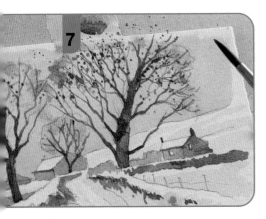

7 Swap to the size 4 rigger for the finest branches, then use the size 6 round to flick on the initial dark mix (i.e. the mix used for the tree trunks, not the finer branches).

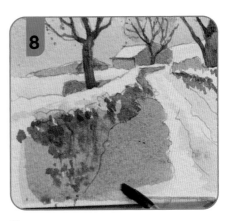

8 Paint the shadow cast by the foreground wall using the size 6 round and a mix of cobalt blue and transparent violet.

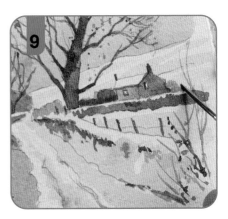

9 Add some final details with the size 6 rigger, using the mixes on the palette. Use the darks for some foreground branches, fenceposts and details on the buildings.

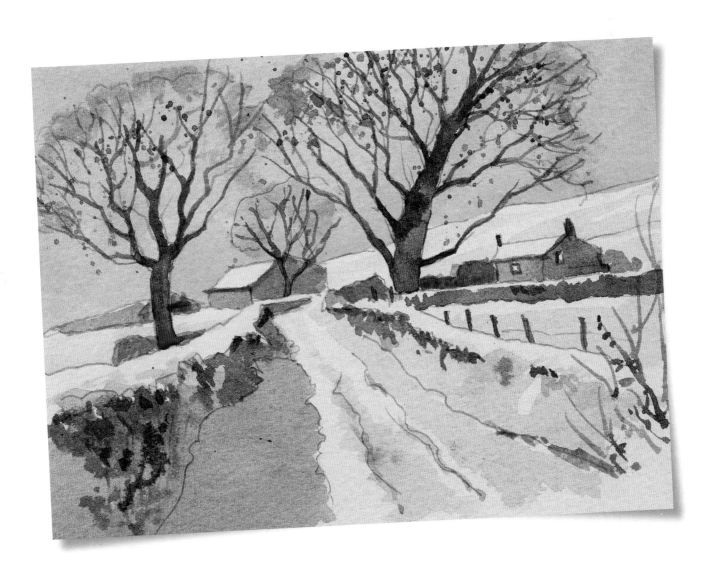

Wintry woodland

YOU WILL NEED

Paint colours: cobalt turquoise, cobalt blue, transparent violet, Indian yellow, lemon yellow, burnt sienna, French ultramarine

Brushes: size 6 round, size 4 rigger

Other: tracing number 30

Imagine walking through a wood after a fresh snowfall, with strong winter sunlight appearing behind the trees and casting lovely long shadows across the snow... what a sublime picture.

1 Start off by using the size 6 round brush to draw watery cobalt turquoise down from the horizon. Add in some cobalt blue and transparent violet to the mix, keeping it equally dilute, and continue to build up the foreground. Add some light spattering to break up the white areas a little.

2 While the foreground dries, turn the painting upside-down. Combine Indian yellow, lemon yellow and burnt sienna. Use this to spatter all over the background trees, then dab the area lightly with a clean finger. Add some transparent violet spatters over the trees near the horizon.

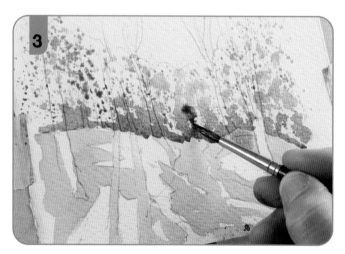

3 Turn the painting the right way up. Mix transparent violet and cobalt blue, and use the size 6 round to paint the darkness along the horizon carefully – make sure the paint leaves a crisp line, in order to create the right contrast between the background and crisp snow.

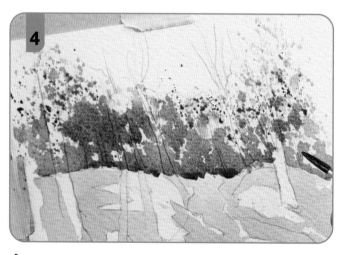

4 Build up the texture in the trees with further spattering of the same colours as before. While the spatters of paint remain wet, work the tip of the size 6 round brush to work along the tree line, using the wet paint that's already there to fill in the colour.

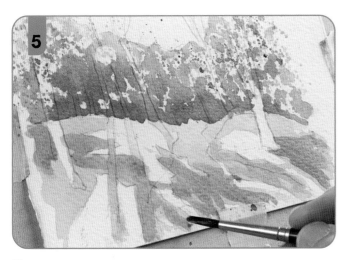

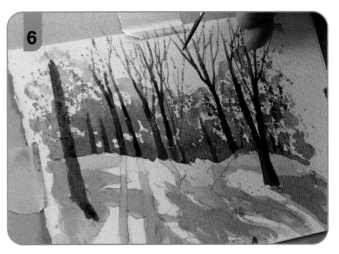

5 Allow to dry completely, then use a mix of cobalt blue and cobalt turquoise to strengthen the foreground with brushwork and spattering.

6 Mix burnt sienna, French ultramarine and transparent violet to make a dark mix at a creamy consistency, then paint in the trees. Use the size 6 round brush for the trunks and main branches, then swap to the rigger for the finer twigs.

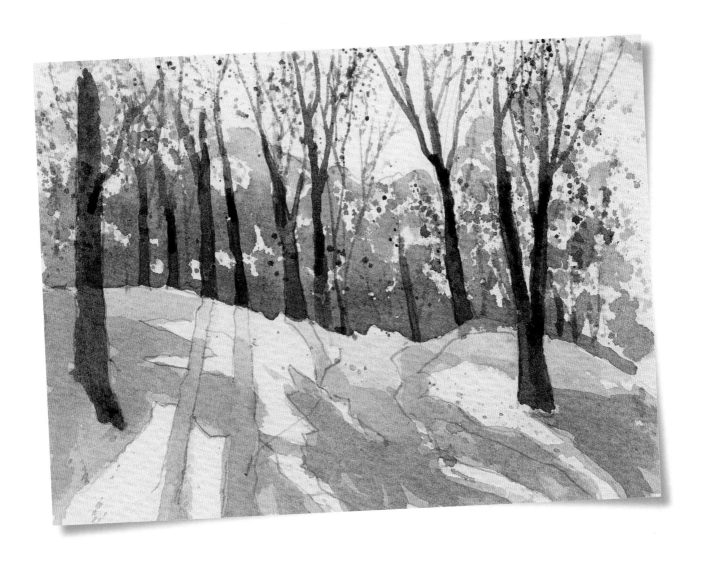

LAKELAND RIVER

See tracing number 31

I hope you have enjoyed working along with me through the exercises, and are now confident to take on what you wanted to do right from the beginning... a finished painting! I find it very beneficial to have a clear idea of what I want to portray in my paintings so that I don't go off half-cocked and hope that 'something' will just manifest itself along the way.

A tonal study, made before you begin, will help you to establish the different elements in your picture, their importance to each other, and the counterchange throughout the scene (light against dark and vice versa). These need only be simple graphite sketches, no bigger than postcard, but they will give you an important plan to work to. An example is shown below.

You will see in this painting that there are trees, rocks and water, a good combination to get your teeth into. Don't get bogged down with techniques. You don't have to incorporate all the techniques into the paintings – only the ones that you need to produce a pleasing result.

The sunlight is catching the right-hand side of the tree trunks, so I have left those areas the white of the gesso. As I moved back into the shadow areas my paint became darker as I moved into the centre. You will notice in the foreground tree that the shadow is less dark at the left-hand edge. This is because it is picking up the reflected light from the tree behind it. As I mentioned in the shadow exercises, it really does pay dividends to observe your scene closely before painting.

As with the trees, I have left the sunlit tops of the rocks as white gesso. The cracks and fissures I have painted in with creamy dark paint using the rigger brush.

This small tonal study gives me my plan of action and concentrates on the main areas of light, dark and mid-tone areas.

After painting in the stream bed, I went over it with a series of semi-transparent glazes of yellows, greens and orange. I finally put in the lights with a mix of white and a touch of turquoise.

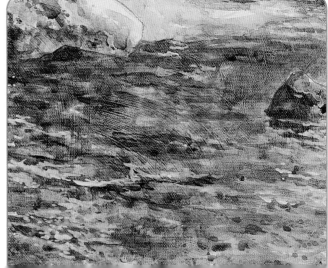

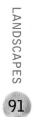

GARWAY VILLAGE

See tracing number 32

We had walked for miles over the rolling Herefordshire countryside when this view of Garway church, nestled amongst all that verdant pasture, took my eye. I have painted this picture up especially for the book so that you can see how I undertake a studio painting from start to finish.

Notice how many of the techniques from the previous exercises are incorporated in this example, and you will get to see how they all come together in a finished painting. In turn, this will show you the process I myself follow for painting, which I hope will inspire you to try your own compositions.

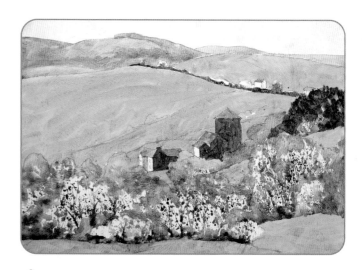

To set the scene. I painted in the background hills with a green/blue wash, before moving forward and adding more yellow to the mix for the fields in the middle distance. The foreground trees received an initial application of various orange, brown and yellow spatters for that underlying texture. I then carefully painted in the church and farm buildings.

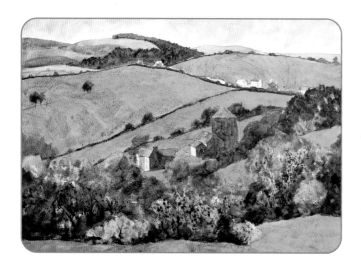

With a slightly creamier mix, I next started to determine the different elements of the scene: the background woodland, the slopes of the different fields, the hedgerows and trees. I also started to build up the structure of the foreground trees, using semi-transparent washes so I did not obliterate the underlying textures.

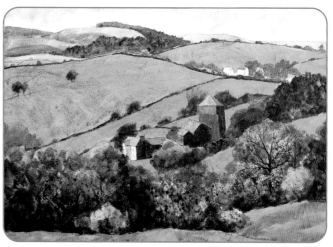

At this stage, the painting was really taking shape. I now concentrated on the darker shade areas of the foreground trees, using an orange, blue and brown mix, taking it down to the field edge. Even this darker mix is not opaque and still allows a certain amount of the textures to show through. The shadow areas of the buildings were carefully painted in at this stage, giving them structure.

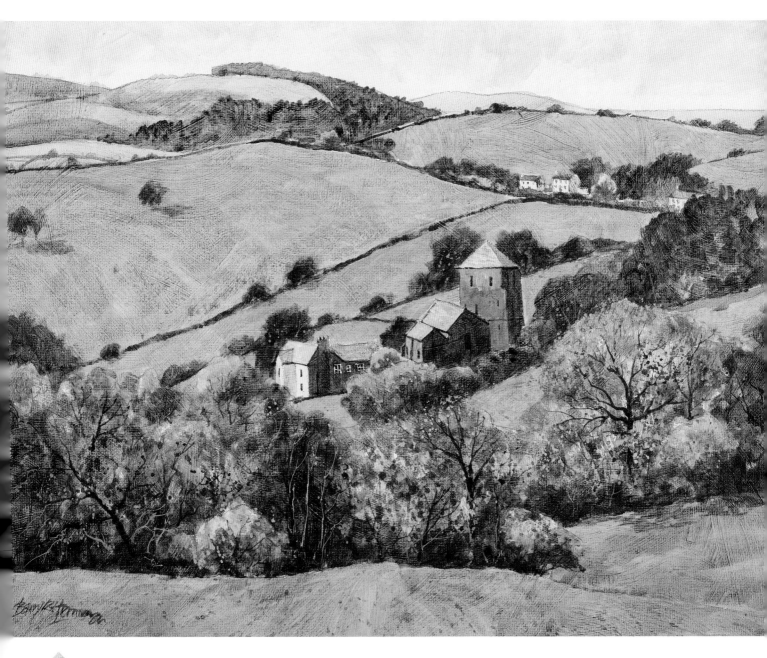

Now for the finishing touches. With all the basic 'groundwork' completed, it is now time to put in those lovely bits of detail that really bring the painting to life. As per the previous exercises, you will see that I like to put in the majority of my details with the rigger, as I think it gives a more painterly feel to the work. You will notice that I have used a little white paint for some of the windows and also for some of the lighter tree trunks and branches within the foreground copse.

TOWARDS ACHILL HEAD

See tracing number 33

Having travelled the length and breadth of Ireland's west coast, I have seen some wondrous sights and have painted a lot of them. Achill Island is one of those exhilarating places with a wealth of painterly scenes all in one place. On one trip to the island, my mate Keith and I undertook an arduous walk from Keem Bay, in an ascent across ankle-twisting bogland to get this view out across to Achill Head. Behind us were the awesome sea cliffs of Croaghaun, which are the highest in Ireland.

We now come to the conclusion of our journey into the realms of painting landscapes in acrylics. I hope I have imparted some of my passion for this incredibly versatile medium, and that you will go on from here to find your own style and creativity. Happy painting!

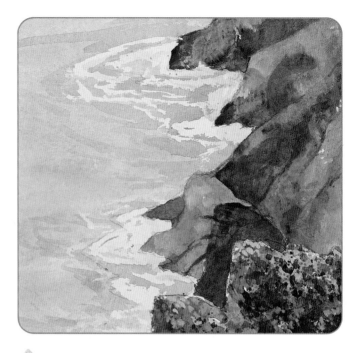

Before I started the painting I used masking fluid to reserve the whites of the foam areas of the sea around the base of the cliffs. I was then able to paint the sea quite freely in the knowledge that my whites would be safe.

There was a slight sea mist clinging to the cliffs which subdued the colours somewhat, so this was a good example of where to use tinting white. As explained one pages 24–25, this white paint is not as opaque as titanium white; instead it produces a pearlescent glaze when mixed with a base colour.

The highlighted rocks againt the darks of the gorse bushes demonstrate counterchange nicely. There is also counterchange within the bushes themselves. Mixing white with the gorse colour, I was able to stipple in some highlights against the darker shadow areas.

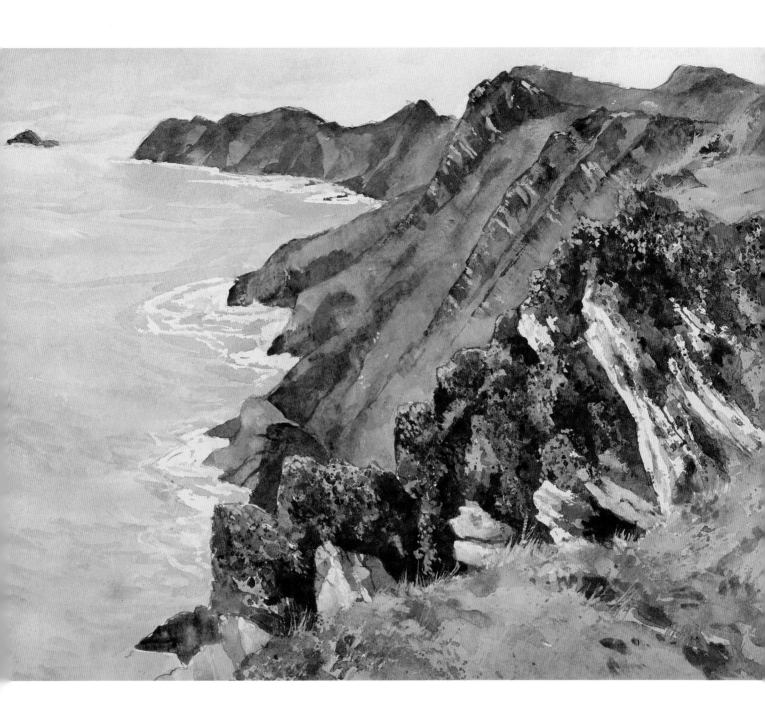

INDEX